LOST
WHITE COUNTY
INDIANA

W.C. MADDEN AND MARIA SALVO BENSON

Published by The History Press
Charleston, SC
www.historypress.com

Copyright © 2024 by W.C. Madden and Maria Salvo Benson
All rights reserved

Cover photograph courtesy of the White County Historical Museum.

First published 2024

Manufactured in the United States

ISBN 9781467154673

Library of Congress Control Number: 2023945817

Notice: The information in this book is true and complete to the best of our knowledge. It is offered without guarantee on the part of the authors or The History Press. The authors and The History Press disclaim all liability in connection with the use of this book.

All rights reserved. No part of this book may be reproduced or transmitted in any form whatsoever without prior written permission from the publisher except in the case of brief quotations embodied in critical articles and reviews.

This book is dedicated to my husband, Matt, and my children for always supporting my passion for writing and history.
—Dorothy Salvo Benson

This book is dedicated to my wife, Janice, for her encouragement and support in my writing endeavors.
—W.C. Madden

CONTENTS

Acknowledgements — 7

1. Native Americans — 9

2. Communities — 13
New Hartford • Wyoming • West Bedford • New Lancaster • Montgomery • Castleton • Mount Walleston/Norway • Black Oak • Nordyke • Palestine • Springboro • Farmington • Sharon • Fayette • Kiousville • Clermont • Idaville/Hannah • Seafield • Wheeler/Smithson • Oakdale/Lee • Buffalo/Flowerville • Headlee • Sitka

3. Gone But Not Forgotten — 24
Billiard Parlors • Blacksmithing • Bus Line • CCC Camps • Coal and Ice Companies • Creameries • Dry Cleaners • Dry Goods Stores • Huckster Wagons • Implement Stores • Liveries • State Banks • Stockyards • Telegraph Offices • Train Stations • Video Stores

4. Almost Lost — 40
Computer Stores • Drugstores • Funeral Homes • Grocery Stores • Hardware Stores • Hospitals • Hotels • Lumber Stores • Meat Markets • Newspapers and Magazines - *Brookston - Buffalo - Burnettsville - Chalmers - Idaville - Monon - Monticello - Reynolds - Wolcott - White County* • One-Way Streets • Telephone Companies

CONTENTS

5. SCHOOLS 64
Brookston High School • Buffalo High School • Burnettsville High School
• Chalmers High School • Idaville High School • Monon High School
• Monticello High School • Reynolds High School • Round Grove High
School • Wolcott High School

6. BUSINESSES 76
Brookston • Burnettsville • Chalmers • Idaville • Monon • Monticello•
Reynolds • Wolcott

7. RESTAURANTS 90
Brookston • Burnettsville • Chalmers • Idaville • Monon • Monticello
• Norway • Reynolds • Wolcott

8. ENTERTAINMENT 103
Bands and Orchestras • Ideal Beach • Roller Skating Rink • Theaters -
Burnettsville - Monon - Monticello - Wolcott • Radio Stations • Tracks

9. ORGANIZATIONS 121
Brookston • Burnettsville • Monon • Monticello • Reynolds • Others

10. MANUFACTURERS 129

11. RESORTS 136

12. OTHER THINGS LOST 144
Bridges • Carriage Houses • Ferries • Fob Watch • Grace House •
Lakeview Home • Orphanage

ABOUT THE AUTHORS 160

ACKNOWLEDGEMENTS

Thanks to all the people who gave us their time and information that went into the writing of this book.

A special thanks to Judith Baker at the White County Historical Society for her assistance in researching the material that went into this book.

The Monticello-Union Township Library was a good source of information for this book with its microfiche files of newspapers.

The book *A Standard History of White County Indiana* provided much of the early history used in this book. Also, the book *On the Banks of Burnetts Creek: The Life and Times of Burnettsville, Indiana* provided some of the information on the town.

1

NATIVE AMERICANS

The Native Americans were the first to settle in the area that would eventually become White County, Indiana. The Miami tribe had one band that lived in the area. They were called Pepikokia and later known as the Tepicon or Tippecanoe band. (*Tippecanoe* comes from the Native American word for "people of the place of the buffalo fish").

The Miami in this area were hostile toward the United States, and some joined forces with Shawnee chief Tecumseh in nearby Prophetstown. Their village was destroyed after the Battle of Tippecanoe by forces sent by William Henry Harrison, the territorial governor, on November 11, 1811. In the battle, Colonel Isaac White was killed while leading a charge. When White County was formed in 1834, it was named after the colonel.

After the battle, the Potawatomi fled north and built two villages along the Tippecanoe River in White County. One village was located on the west bank of the river, half a mile north of Monticello, and the other was five miles farther north on the east bank, near what became known as Holmes' Ford in Liberty Township. This village comprised nearly one hundred wigwams and some three hundred Native Americans when white settlers arrived in the early 1830s. They had three or four acres of farmland adjoining the village, where they grew corn, pumpkins, squashes and potatoes. They also hunted and fished. They were hospitable, dirty beggars and neither their cooking nor their personal habits appealed to settlers.

The settlers in the White County in 1832 had a few scares from the Native Americans as the Black Hawk War waged in nearby Illinois and Wisconsin.

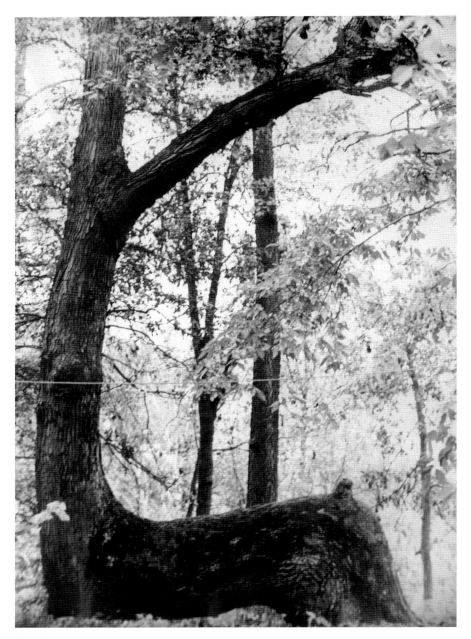

The Native tribes used to bend trees when they were young to identify paths to take. This one is in White County, but its location is kept a secret. *White County Historical Museum photograph.*

Reports of Native massacres gave them a general feeling of alarm, and they reacted by gathering together and preparing themselves. About the first of June, the families living in White County packed up their household goods in wagons and fled to older settlements in the Wabash Valley. Some people set fire to the grass on the Grand Prairie to stop any warriors from following them. A small company of men was formed in Delphi under the command of Captain Andrew Wood. The well-armed men came through White County and kept an eye out for oncoming Native Americans. None came, and the men returned to Delphi.

Later in June, some twelve to fifteen families in the county made formidable preparations by building a blockhouse near the mouth of the Spring Creek in Prairie Township. The Potawatomi were just as concerned and went to the Indian agent for advice and protection. They thought the white settlers were going to attack them. However, no attacks from anyone came about, so the settlers went back to their farms, and the Potawatomi went back to the wigwams in peace.

The Potawatomi gave up their Indiana lands on October 16, 1826, when a treaty was signed. In May 1830, President Andrew Jackson signed the Indian Removal Act, authorizing an exchange of lands with the Natives residing in any of the states for their removal to land west of the Mississippi River. This eventually led the way for the removal of the Potawatomi from Indiana. The Potawatomi chiefs sold much of their remaining land in the 1832 Treaty of Tippecanoe. The last of the tribe were moved to Kansas in September 1838 in what would become known as the "Trail of Death," as more than 40 died on the forced march of 859 Potawatomi to Kansas by a company of militia, including a couple of men from White County.

The militia burned their fields and houses to minimize the temptation for the Potawatomi to try to escape and return home, according to "Trail of Death," by the Citizen Potawatomi Cultural Heritage Center. According to *Counties of White and Pulaski, Indiana*, one witness to the event wrote:

> *It was a sad and mournful spectacle to witness these children of the forest slowly retiring from the homes of their childhood. As they cast mournful glances backward toward the loved scenes that were fading in the distance, tears fell from the cheeks of the downcast warriors, old men trembled, matrons wept, the swarthy maiden's check turned pale, and signs and half-suppressed sobs escaped from the motley groups as they passed along, some on foot, some on horseback and others in wagons—sad as a funeral possession. I saw several of the aged warriors casting glances toward the*

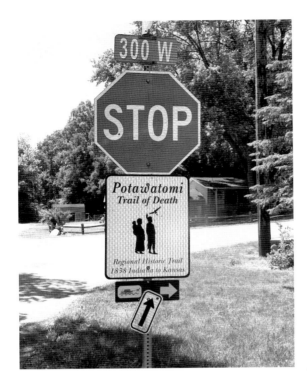

Signs like this one identify the Potawatomi Trail of Death, a Regional Historic Trail. This one is located on the Towpath between Monticello and Logansport. *W.C. Madden photograph.*

sky, as if they were imploring aid from the spirits of their departed heroes who were looking down upon them from the clouds, or from the Great Spirit who would ultimately redress the wrongs of the red man, whose broken bow had fallen from his hand and whose sad heart was bleeding within him.

The last of the Miami tribe in the White County area was sent to their reservation in Kansas in 1846.

The Pokagon band of Potawatomi—the only part of the tribe not sent to Kansas—lives in southern Michigan and opened the Four Winds Casino.

2

COMMUNITIES

In the 1830s, many areas in the northern part of Carroll County were beginning to be developed, so the state decided to create White County. Early settlers gathered in settlements that eventually turned into either villages or towns. However, some villages never materialized into towns and disappeared from the farmland around them. They died out for several reasons. The invention of the automobile started making it possible to travel farther distances quickly, and this meant the end of the horse as the main means of transportation. Then came the Great Depression in the 1930s. School consolidation in the 1960s was the final straw for some communities, as businesses moved and made them ghost towns for business.

Several settlements developed in White County in its early days. They were merely a cluster of homes with a school built for the area's children or perhaps a church where residents could practice their religion.

NEW HARTFORD

The oldest community not to survive was New Hartford. Abel Line laid out the village with seventy lots and a public square on January 20, 1837, about two and a half miles east of Monon. The town never developed.

This diagram shows the towns that were platted but never turned into towns. *Carolyne J. Piske art.*

WYOMING

The next town to be laid out was Wyoming on the west bank of the Tippecanoe River, half a mile south of the Pulaski County line. Crystal D.W. Scott, a New Light minister, laid out the town with sixty-four lots on February 24, 1837. He described it as "handsomely situated on the bank of the Tippecanoe River, where the Rochester and Monticello road crosses said river," according to the *Standard History of White County*. Unfortunately, the proposed state highway was placed elsewhere. Not one lot was ever sold.

WEST BEDFORD

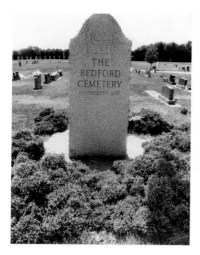

The only thing remaining of the town of West Bedford is the Bedford Cemetery, which was created in 1837. *W.C. Madden photograph.*

The town of West Bedford was platted by David Berkey on April 21, 1837. Located on the north side of the Little Monon Creek and west side of the Big Monon Creek, West Bedford contained one hundred lots. The community flourished for about fifteen years. Several saloons sold whiskey and gin. When the Louisville, New Albany and Chicago Railroad was built three miles west of it, the new town of New Bedford was platted, and the residents of the area moved there. All that remains of the original West Bedford is the Bedford Cemetery.

NEW LANCASTER

Next to be laid out was New Lancaster on October 13, 1837, by David Lambert. The town was to be located on the west bank of the Tippecanoe River. The town comprised eight blocks divided into sixty-two lots; however, nothing came of it.

MONTGOMERY

Three days after New Lancaster came Montgomery on the east bank of the Tippecanoe River. It was to rival New Lancaster with its sixty-four lots and public square, yet it never materialized either.

CASTLETON

A year after Montgomery was platted, the town of Castleton was laid out by Cyrus B. Garlinghouse on February 28, 1838. It was to be located one mile east of the present town of Idaville with forty-eight lots. Like the others, it never came about.

MOUNT WALLESTON/NORWAY

Mount Walleston was first formed in March 1845. Hans Hiorth bought one thousand acres of land north of Monticello. The Norwegian first called the area Mount Walleston, after the ship that brought him to America. After he died of consumption, his wife, Bergetta, had it laid out with ninety-six lots along the west side of the Tippecanoe River. In the late 1800s, the Norway School was built there. The building was later used by the Norway Pilgrim Holiness Church. Now, it is the home of a business called Norway Gardens. In 1923, the Norway Dam was built on the river. The area became known as Norway, but it never developed into a town. Several thriving businesses are located there. Norway borders the city of Monticello, but the city has no plans of annexing the area, according to Mayor Cathy Gross.

BLACK OAK

One of the first settlements in the 1840s was called Black Oak in Princeton Township. It was named after the enormous black oak trees there. A round log schoolhouse was built there. The one-room schoolhouse burned down in the early 1890s. A new building was constructed and used until it became obsolete. The school was used as a community center, church and a place for Sunday School meetings. The settlement died out, and farms took over the landscape. The Black Oak settlement was located about five miles north of Wolcott, near the Pulaski County line.

NORDYKE

Another nearby settlement just south of Black Oak was called the Nordyke Settlement, after the Nordyke family who lived there. A school was built there around the same time in the mid-1840s.

PALESTINE

The Palestine Settlement began in Princeton Township. A school was built at the settlement in the 1840s. A church was also built in the settlement. The community lasted into the 1900s before disappearing.

SPRINGBORO

The Springboro Settlement developed five miles east of Brookston in the 1840s, and a general store was built there. A post office with that name existed there from 1851 to 1853. The area was considered a good site for a dam, but after the Norway and Oakdale Dams were built, the idea was dropped. A general store is still at the site.

Then there were some areas that were platted but never developed or died out completely.

FARMINGTON

In the 1850s, the area near the Burnett's Creek Post Office was called Farmington, yet that name was abandoned on March 29, 1854, when the town of Burnettsville was platted by Franklin J. Herman.

SHARON

In 1861, the town of Sharon was laid out on the far east side of the county by Thomas Wiley and James B. Elliott. The town was formed because the Logansport, Peoria and Burlington Railroad was coming through the county. Then on December 7, 1880, William Irelan made an addition of sixteen lots to the town. James D. Brown added another twenty lots to the site in October 1897. Sharon was then absorbed by Burnettsville.

FAYETTE

Some years later, Fayette was laid out in Princeton Township, east of Wolcott, by Harris Shaw on March 18, 1856. Shaw platted sixty-four lots four years before the railroad passed through the area. However, the town never developed.

KIOUSVILLE

Then on November 25, 1856, John Kiocus platted the town named after himself, Kiousville. It was located a mile north of Brookston. The town was laid out in four sections with nearly two hundred lots, but it never developed.

CLERMONT

The town of Clermont was laid out in Princeton Township, just north of Wolcott, by Christopher Hardy on April 2, 1860. It never developed.

IDAVILLE/HANNAH

Idaville was also laid out in 1860, and it was originally known as Hannah. While it got larger and came to house many businesses, it never became a town. A post office has been there since its inception, and there's a fire station. Two annual tractor pulls behind the old fire stations are big draws that entertain more than five thousand people.

SEAFIELD

The town of Seafield was platted by M.C. Hamlin in 1863. He made up 145 lots north and south of the railroad that was to run through it. Seafield was located halfway between Reynolds and Wolcott. Supposedly, it was named Seafield because when the fields filled up with water, it looked like a sea. A general store was built there in 1877, as was a post office. A school was built a mile north of the town. The school was later moved to the town and named the Koppenstein Grocery Store. In 1888, another school was built in the town. A church was also built there later. An elevator burned there on August 29, 1926, and twenty-five thousand bushels of grain were lost. The only thing left there today is a cluster of homes and farms. A sign on U.S. 24 directs people to a town that no longer exists.

Communities

This tractor blows an engine in a run at the Idaville Tractor Pull. The semiannual pull is a very popular event in Idaville and is sponsored by the Idaville Fire Station. *Bill Ray photograph.*

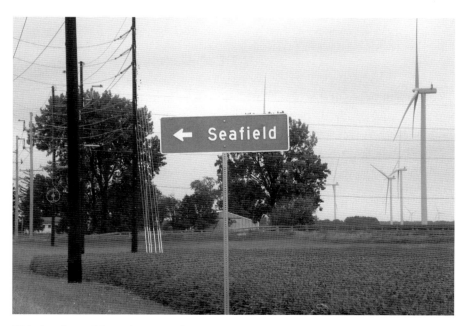

This sign shows drivers the way to Seafield on U.S. 24, but drivers will find only homes there today. *W.C. Madden photograph.*

WHEELER/SMITHSON

In the 1880s, the town of Wheeler was platted by farmer Hiram M. Wheeler between Chalmers and Reynolds alongside the Louisville, New Albany and Chicago Railroad. At that point, the Smithson Post Office was established inside Wheeler's general store. The post office was named Smithson after a Civil War veteran, Bernard G. Smith, who came to the neighborhood in 1846. The railroad station was also called Smithson. The small town then became known as Smithson. The post office was discontinued in May 1931. The general store became known as Schroeder's General Store, which was shuttered a long time ago. The building was then used as a warehouse for storage. A tornado struck the building on March 31, 2023, and it now lies in ruin. A sign directs people from Indiana 43 to a town that no longer exists.

OAKDALE/LEE

In 1886, the town of Oakdale was platted with 120 lots by Benjamin A. Linville and Noble J. York. It was located one mile from Jasper County and five miles northwest of Monon along the Louisville, New Albany and Chicago Railroad. A post office was already in the area and was named Lee, after John Lee, the president of the ID&C Railroad, who opened a grain market there. The area became an important shipping point for hay and grain. A general store was built there, as was a school. The school was the last one-room schoolhouse to close in the township in 1939. The Lee Methodist Episcopal Church was built in 1903 and was remodeled in 1950 and 1960; however, it closed its doors in May 1985 and lies in ruins today. Nowadays, all that remains of Oakdale/Lee are about a dozen homes and the railroad track.

BUFFALO/FLOWERVILLE

The year 1886 also marked the platting of Buffalo about ten miles north of Monticello on the Tippecanoe River. A post office across the river was named Flowerville, but the area was never platted. Buffalo developed enough to have a high school built there and then an elementary school; however, the North White School Corporation decided to close the elementary school

Communities

This old general store building was built in 1900, and it is all that remains of a community once called Smithson. It was for sale for $27,900 in 2023, but then it got hit by a tornado on March 31. It was owned by Robert D. and Anna M. Hadley of Chalmers. *W.C. Madden photograph.*

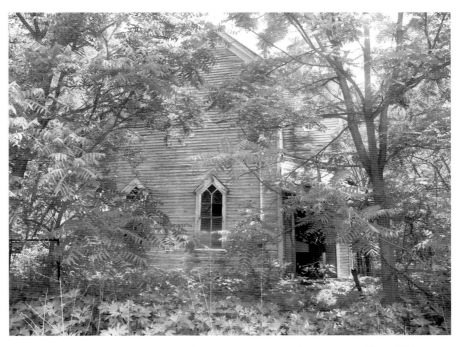

The Lee Methodist Episcopal Church is falling apart in the former town of Lee. *W.C. Madden photograph.*

The Buffalo Fire Station provides protection for the surrounding community and area. *W.C. Madden photograph.*

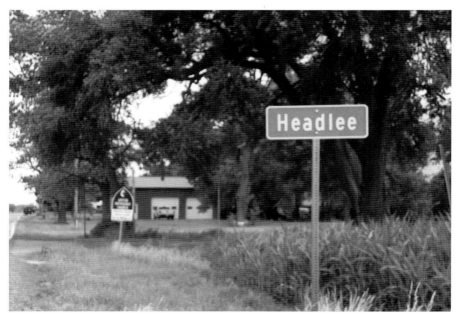

The only thing remaining in Headlee is its sign saying it was once a community. *W.C. Madden photograph.*

COMMUNITIES

in 2012, leaving behind its ninety-six children. That left the community with a lot of homes, a post office, a couple of churches and businesses and a cemetery. However, it's an unincorporated area, not a town.

HEADLEE

The town of Headlee was platted in November 1888 and named after Harvey Headlee. A post office was established there in 1870 and remained in operation until 1907. The Headlee Church of God was built there in 1890 and was renovated in 1921. The town also had its own school. Then came a creamery, five gas stations, a poolroom and an ice cream parlor. A volunteer fire department was also formed. By the 1950s, the Headlee Church of God was still thriving, and the town had a private airport that was used for micro-midget racing. It also had Heiny's Grocery Store. Big auctions and square dances were held in the town, too. Then the town began to die and was never incorporated. Now, there are no businesses in the area, and the old church has been converted into a home. All that is left are the memories.

SITKA

The hamlet of Sitka was founded in the southern part of Liberty Township in 1880, and a post office was established there, with M. Allison Hughes as the postmaster. Later, a one-room schoolhouse, a general store and a church were built there. However, it never developed enough to form a community.

3
GONE BUT NOT FORGOTTEN

Progress has a way of leaving behind some industries and ways of life, and such was the case with several ways of life and businesses in White County.

BILLIARD PARLORS

Billiard parlors were popular in the 1900s, and several communities had them at one time or another. C.E. Baker had one at 109 North Main Street in Monticello in the early 1900s. Now, the game can be found in bars in the community instead of one business relying on it.

BLACKSMITHING

Blacksmithing existed as early as 1500 BCE, so it has been around for a long time. Blacksmiths were central to medieval life and set up in the center of villages. The Industrial Revolution resulted in their decline. Blacksmiths were essential in White County before the automobile became the more popular mode of transportation in the 1920s. A blacksmith was in about every town, as horses needed shoes, and other metal goods were made locally by them.

Condo and Jenkins was located in Monticello at 116 West Marion Steet in the late 1800s and early 1900s. By 1920, it was known only as L.E. Condo. The building was recently demolished.

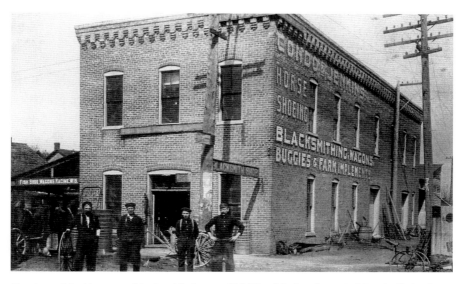

Condo and Jenkins was a blacksmith shop at 116 West Marion Street in Monticello in the late 1800s. It sold buggies, farm implements and wagons from Fish Brothers in Racine, Wisconsin. The building was recently torn down to make room for a parking lot for community corrections. *White County Historical Museum photograph.*

T.D. Beard, B.L. Carr and Charles Nethercutts were blacksmiths in Burnettsville in the early 1900s. Arthur Renwick had a blacksmith shop in Idaville in the 1920s.

A few blacksmiths still exist, but there are none in White County. The closest one is in Camden in Carroll County.

BUS LINE

Fred Sawyer of Monticello ran a bus line during the 1910s. He started with new Ford cars that hauled people from Monticello to Burnettsville and Kentland.

CCC CAMPS

During the Great Depression, the government started the Civilian Conservation Corp to help give work to young men from unemployed families. The program began on March 21, 1933. The program was

part of President Franklin D. Roosevelt's New Deal legislation written to combat unemployment. One of the camps began operations a mile north of Monon. The camp was for boys and young men, but local men who couldn't find work could enlist as well. They were furnished with clothing, food, beds and rooms. They were treated like soldiers and received weekend passes to go home. They worked on roads and cleaned up brush after storms, and they were given other duties. The program lasted until it was defunded in 1942, after America entered World War II against Japan and Germany.

COAL AND ICE COMPANIES

Coal and ice companies were popular in the early 1900s, when people heated more with coal and had iceboxes, the first type of refrigeration. Coal was used extensively in homes and businesses to feed furnaces. Many homes had a coal chute going into their basement so that the black rock could be transported to the furnace easily. The companies sold large blocks of ice that could fit in iceboxes to keep things cold.

Some companies began selling coal and lumber but later switched. Fred P. Biederwolf owned a coal and lumber company before switching to Biederwolf Coal and Ice Company at 588 South Illinois Street in Monticello in the 1920s and 1930s. Joseph Vanscoy was the Natural Ice Dealer.

Refrigerators replaced iceboxes, so large blocks of ice were no longer needed. Coal furnaces were also replaced by natural gas and oil furnaces.

CREAMERIES

Creameries began to pop up in the 1920s but were short-lived, as they only lasted a couple of decades. A creamery purchased cows' milk and eggs from farmers to make butter and cheese. The Golden Rule Creamery operated in Monticello in the 1920s at the corner of North Main and Market Streets. Armour Creameries were located in Monticello and Wolcott. Schlosser's Cream Station had locations in Monticello and Burnettsville in the 1920s. Reynolds had four cream stations operating in the 1920s: Fowler's Cream Station, Lawrie Trucking Service and Cream Station, Purdue Creamery and Ruppert Bros. Cream Station. Sherman White Creamery was in operation in Idaville in the 1920s.

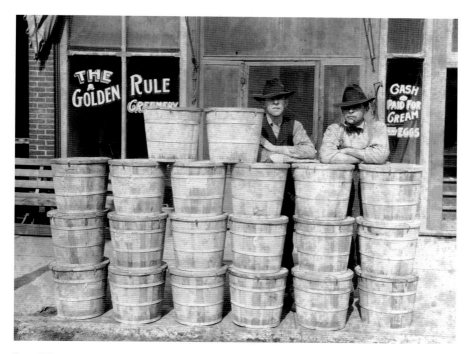

Lero Hines (*left*) and Loyd Kilmer stand in front of their store, the Golden Rule Creamery, at the corner of North Main and Market Streets in Monticello, where Abe's Pizza is located now. *White County Historical Museum photograph.*

The creameries died out as grocery stores began selling the same products. Creameries these days specialize more in making ice cream.

DRY CLEANERS

The dry cleaning business became prominent in America in the 1900s, after specialized machines were invented. Years ago, about every community in the county had a dry cleaner to take care of cleaning clothes without having to wash them. Nowadays, these businesses are few and far between, and in White County, there are none, as they have been taken over by laundromats that send the clothes to Lafayette to get dry cleaned.

In the 1950s, Monticello had six dry cleaners. That was a lot for a city of fewer than five thousand people; however, dry cleaning was more popular then than it is today. The dry cleaners were A-1 Cleaners at 706 South Main Street, Band Box Cleaners, Carroll Cleaners at 209 North Main Street,

The Monticello Dry Cleaners building in Monticello is now the home to Peach Pickers Market, an antique store. It is owned by Antonelli Dino, and his wife, Jackie, runs the market there. The building was constructed in 1931. It once housed the Clyburn Manufacturing Company, which made machine parts during World War II, according to Jackie. *W.C. Madden photograph.*

Jefferson Cleaners at 522 West Jefferson Street, Maiben's at 202 Ireland Street and the Nicholas Cleaners at 706 South Main Street.

The last dry cleaning place in the county was the Monticello Dry Cleaners on North Main Street, and it went out of business at the beginning of the twenty-first century. Now, clothes that need dry cleaning are dropped off at Life's a Beach Wash and Tan on Sixth Street or at Peerless Cleaners on 719 North Illinois Street. These are both laundromats.

DRY GOODS STORES

Dry goods stores were common in the 1800s in White County; however, this concept eventually faded away, and stores started going by different names, although they sold the same things that dry goods stores once sold.

Rowland Hughes built Rowland's Dry Goods Store in Monticello in the 1850s. The term *dry good* is a historic phrase describing the type of products a store carries. It meant the stores may have had fabric, thread, clothing and commodities traded in bulk, like tea, sugar, coffee and grain. These things

did not contain any liquid. Big box retailers, like Sam's Club and Costco, have taken over the role of dry goods stores.

In 1914. Mrs. D.D. Phillip ran a dry goods and millinery (women's hats) store in Monticello at 107 South Main Street, and J.B. Roach also ran a dry goods store. William Beshoar had a dry goods store in Burnettsville, but it eventually became a general store. Frye and Ullery had a combination dry goods and grocery store in Buffalo.

In the 1920s, Henry Darling had a combination grocery and dry goods store.

The stores began to dwindle with the rise of department stores and good transportation.

HUCKSTER WAGONS

In the 1800s, horse-drawn wagons filled with dry goods, medications, seasonings, "snake oils" and other wares would go to all parts of the country. Customers looked forward to these visits from the hucksters. They listened for the familiar clanging sounds of the wagon stopping outside their front doors. They might trade some butter or eggs for goods such as straw hats, flour, brooms, saws, spices or work boots. They also liked to hear the latest gossip. In the Sitka area, Charles Fross delivered goods from his store in the early 1900s. Billy Shell operated a huckster wagon from his store in Buffalo.

Love and Marsh started a huckster wagon in Burnettsville in April 1896.

In the village of Smithson, Herman Schroeder built a general store in 1897 and started driving a huckster wagon to sell goods to farmers in the early 1900s. He used a mule hitched to a wagon to carry his merchandise. In 1915, he upgraded to a truck that had a chain-driven two-cylinder engine under the seat, but he still used the mules for hard-to-get-to farms, since roads were still in poor condition. His son Ed took over the wagon in the 1930s, and it was likely the last of its kind in White County in the 1950s. "I had six routes a week," said Ed. "Each day, I went in a different direction, and I stopped at every house."

In the village of Norway, Bert Coy owned a store and delivered goods using an International truck outfitted as a huckster wagon.

The huckster wagons were replaced by ice trucks, milkmen and the bread man. Today, Schwan's Home Delivery of Monticello carries frozen goods to farms and homes in the country.

IMPLEMENT STORES

One hundred years ago, there were implement stores that sold farm tools in the county. They have all been replaced by one store in Monticello, GreenMark Equipment, which sells John Deere farm equipment. Ed L. Parrish had a combination hardware and implement store at 219 North Main Street in Monticello in 1914. The Kanne Implement Dealer was in Monticello in the 1920s and 1930s.

Some of the other towns in the county also had implement stores, such as the Monon Implement Store in the 1920s, the Gross Implement Store in Brookston in the 1930s and the Fowler Implement Company and Meadow's Farm Implements in Wolcott in the 1930s.

LIVERIES

Back in the 1800s and early 1900s, many communities had a livery, which was a stable for the feeding, stabling and care of horses. Of course, the horse was the favored mode of transportation until the automobile was invented and came into common use in the area in the 1920s. In the early 1900s, Burnettsville had the Stine and Gardner Livery until Bert Stine bought out J.L. Gardner's interest in July 1906. Charles Timmons had a livery in Idaville until the 1920s. R.L. Livery may have been the last of its kind in Monticello.

STATE BANKS

State banks were in most towns in White County, and many of them formed in the late 1800s or early 1900s with assets of $10,000 to $25,000. All the state banks in the county have either failed or merged with other larger banks. They are all gone.

The first state bank in the county may have been the Bank of Brookston, as it was organized as a private institution on April 14, 1894, by John C. Vanatta. Two years later, it became a state bank with capital of $25,000. When the state bank ended is unknown.

The State Bank of Burnettsville lasted the longest of all the state banks that were created in White County. It was founded in 1904 as the Bank of Burnettsville, a private bank. W.C. Thomas and John C. Duffey started the

bank with capital of $10,000. It later became the State Bank of Burnettsville. The company opened a branch office in Monticello some years later. The bank merged with the Fountain Trust Company on March 9, 2020.

Another state bank that lasted into the twenty-first century was the Farmers State Bank. The bank was founded by Joseph Kious, the grandfather of Brookston philanthropist Junita Waugh, in 1905. The original bank offices were located on Railroad Street between Third and Fourth Streets. Later, it was relocated to a new building at 111 West Third Street. Junita's father, L.A. Waugh, sold the bank to the Garrott family in 1945, with John F. Garrott serving as its president. New technology made the Third Street building obsolete, so it moved its operation to a modern building at 309 South Prairie Street. The bank merged with the Fountain Trust Company on July 15, 2017, and its history ended.

Another Farmers State Bank, no. 360, was located in Monticello and was organized on February 2, 1911. The bank was located on West Broadway, and by April 1, had $25,000 in capital, according to the *History of White County*. When it disappeared is unknown.

The State Bank of Monon was organized on July 2, 1906, with capital of $25,000. It had about sixty-two stockholders, according to the *History of White County*. William S. Baugh was its first president. It moved into a new building that was constructed in 1913. Baugh was the bank's president until 1922. Then the bank's vice-president, Dr. John Stuart, took over the bank.

Dr. Stuart was a remarkably educated man, according to Mike Morris, who did a presentation on the bank at the annual gathering of the Monon Civic Preservation Society on June 16, 2023. Dr. Stuart was born in Manor Hamilton, Ireland, in 1845. His parents moved to Toronto, Canada, where he attended college and graduated with high honors. He learned how to speak eight languages. He received a bachelor's degree in divinity in Toronto. Then he received his master's degree at Illinois Wesleyan University in Bloomington, Illinois. He was ordained in Christian ministry in 1877. He then began preaching at Baptist churches all around Ontario. He became concerned about the stress to his heart, so he decided to become a doctor in the mid-1890s. He went to Barnes Medical School in St. Louis, and in 1897, he completed his medical degree. After college, he went to Monon to practice medicine at the age of fifty-two. He practiced for another thirty years and had exceptional skills in treating cancer and chronic illnesses, so people came from miles away for his advice. In 1910, he was hired as the vice-president of the State Bank of Monon. Dr. Stuart died in 1927, and people lined the streets for is funeral. At the time of his

passing, he had over $125,000 worth of Liberty Bonds and over $100,000 in cash, and he had stock in the bank. In other words, he was loaded.

When Dr. Stuart was vice-president, he hired Carl C. Middlestadt as a cashier. Middlestadt was from a prominent family and became a notable businessman and entrepreneur in Monon. He was well known and well respected. He owned two car dealerships, a restaurant and service station. He also owned a grain and poultry farm. He also had other investments and was the town manager and treasurer at one point. He was one of the most popular men in the small town. Carl was born in 1877 in Medaryville and married Maud Pernell in 1898. They had two children, Leo and Wilhelmina. Leo later graduated from Northwestern University, and Wilhelmina graduated from Indiana University. Carl was also a shareholder in the bank. He was a member of the International Order of Odd Fellows and a member of the Masonic Lodge, where he was a thirty-second-degree Mason, one of the highest ranks in the lodge. He was also a member of the Methodist Church. As a cashier, he oversaw the everyday business of the bank.

J.S. Treanor became the third president of the bank after Dr. Stuart's passing.

The bank and the town were doing well during the Roaring Twenties, when there was a lot of prosperity after the end of World War I in 1918. Then on October 29, 1929, also known as Black Tuesday, the stock market crashed, and the bank shut its doors like many other banks as people ran to the banks to try to get their money. However, this occurred in the days before banks were federally insured, and the banks didn't keep a lot of cash on hand. The money they had was tied up in loans and other investments they made.

The next day, the board of directors met and discussed the problem. They found an $8,000 discrepancy on the books. At the meeting, Clerk Middlestadt said he would go talk to Stuart's son, Robert, in Evanston, Illinois. Robert was a large inheritor of his father, who owned a lot of stock in the bank and happened to be a federal bank examiner. The following day, Middlestadt sent a telegram to Robert from Kankakee, Illinois, but the content of the telegram is unknown. A bank examiner came to the bank on November 1 and confirmed the $8,000 discrepancy, but he believed the number could be higher. On November 7, Middlestadt and his wife, Maud, were seen leaving the town in a new green Chevrolet sedan. The next day, the state banking department closed the bank. Its assets were liquidated. Bank customers received pennies on the dollar for the money they had kept in the bank. Later, the shortage grew to $69,000, which is equivalent to $1 million

today. Bad loans were said to be the cause of the problem. On November 12, Leo, Carl's son, was in Rensselaer, attempting to sell the sedan. Police asked him about the car, but he wouldn't provide any information. A couple of weeks later, White County prosecutor Ralph Scowden issued an arrest warrant for Carl for banker's embezzlement. A missing person's bulletin was issued. A $2,500 reward for Carl's arrest was then issued by a Monon-based organization. A railroad detective, Eddie K. Wallace, vowed to catch Middlestadt and began his hunt for the fugitive. On February 6, 1930, the Farmers Trader Bank of Monon was closed by the State Bank of Accounts. Account holders received a fraction of what they were owed.

Wallace, who was a depositor of the bank, was led to St. Louis in June 1933 to search for Middlestadt. With the help of Detectives Walter Cade and William Washer, he found Middlestadt on June 15, 1933. Carl was living under an assumed name, Charles Weismire. He revealed his real name and explained to police, according to a newspaper clipping, "The whole trouble started when officials of the bank loaned money to some of the businessmen of Monon....They were unable to meet the loans and, after the president died, the responsibility to make good on the loans fell onto my shoulders. In an effort to make good, I falsified the books. Now I cannot tell you just how much money was involved in the loans. I did not get a cent of the money from the bank, nor did I take any of the bank's funds."

Unfortunately, Wallace didn't get a penny of the reward money because the offer had expired. However, he did get the satisfaction of catching Middlestadt, who had been living a very meek life with his wife in St. Louis, since he hadn't stolen any money from the bank. They were living in a small second-floor rental apartment, and he had begun selling novelties house to house. He willingly returned to Indiana under police custody. Extradition wasn't required. He was charged with four counts of forgery and banker's embezzlement. He was represented by Attorney A.K. Sills of Lafayette.

At the trial, Middlestadt told the court that he had not stolen any money. He was asked if he had lost any money on the stock market, and he replied he didn't have any money in the market. He said the only mistake he made was leaving Monon. He claimed that the bank had made some bad loans—one was to the Monon Produce Company, which had taken a loan from the bank in the estimated amount of $70,000. Owner William Brown's store failed around 1925, and he opened a new store in Logansport with some of the money the bank had loaned him. When the loan occurred was unknown, but it was made while Dr. Stuart was the president. A loan of that amount would have been approved by the president and possibly

the board of directors, not the cashier. Middlestadt said he was induced to grant the loan by another officer of the bank who had since passed away. He was referring to Dr. Stuart, who was a well-respected man, but he didn't want to blame him. Middlestadt made a personal loan to the bank of $15,000 to help keep the bank afloat, and he produced the notes to show this at his arrest.

Sills worked out a deal with the prosecutor. Middlestadt would plead guilty to one count of forgery for falsely signing a $200 bank loan at the time of examination so the bank examiner would not find the aggregate amount of the loan to Monon Produce. The other charges were dropped. He was sentenced to serve two to fourteen years at the Michigan City Prison and fined $1,000. After his release from prison, he returned to St. Louis. He went to work at the Hotel Lincoln. His son, Leo, also moved to St. Louis to be with his parents. Maud died in 1944, and Leo passed away in 1948. Carl moved to a retirement home in Louisville and passed away in 1957 at the age of seventy-nine.

"He might have been a real live George Bailey," said Morris. Bailey oversaw his bank when it almost failed in the movie *It's a Wonderful Life*. Bailey saved the bank with his own money that he was going to use for his honeymoon. "Interestingly enough, the amount [of] money missing in the movie was the same, $8,000," added Morris.

The State Bank of Monon joined the ranks of the many banks that failed over the next couple of years. It was the beginning of the Great Depression, which lasted into the 1930s.

In 1890, the Bank of Monticello was organized as a private institution with capital of $5,000 paid in, according to the *History of White County*. Five years later, on October 30, 1895, it became the State Bank of Monticello with capital of $25,000. By 1914, it was advertising in the newspaper that it had $80,000 in assets. The bank was located at 119 North Main Street, and Flagstar Bank now occupies the space. The bank weathered the Great Depression, but it disappeared from the phone books in the mid-1940s.

Then there was just one bank in Monticello—the State Bank. It later acquired a Savings Bank and became the State and Savings Bank. Wells Fargo took over the location, and it was sold by the State and Savings Bank in 2018 to Flagstar Bank. The building was first constructed in 1911 and was renovated in 2001 and again in 2012.

The State Bank of Wolcott was established as a private institution in 1886, with Robert Parker as its president, according to the *History of White County*. The bank continued until 1904, when it was incorporated as a state bank,

with E.D. Dibell as its president. The bank was established with $25,000 in capital and deposits of $160,000, and at one time, it was the oldest bank in White County. Dibell was succeeded by W.E. Fox as president in 1912. However, it became a victim of the bank moratoria that swept the country in the 1930s.

Even the small towns of Chalmers, Idaville and Reynolds had state banks at one time. The State Bank of Chalmers began in 1904 as the Bank of Chalmers. It later became a state bank and had capital stock of $50,000 in 1906, according to newspaper reports. The building where the state bank was located was torn down, and a new building was constructed there in 1956 for the American Legion post.

The State Bank of Idaville was organized in 1898. In 1931, the bank closed its doors, as people had lost their confidence in it. People withdrew their money until the bank had no recourse but to close its doors.

The Bank of Reynolds was established on April 21, 1897. In 1914, it was reorganized as a State Bank with capital stock of $25,000. It weathered the Great Depression of the 1930s but later went out of business.

STOCKYARDS

Stockyards are places where cattle, sheep, swine or horses are kept temporarily until they can be slaughtered for the market.

At one time, there were three stockyards in the county in Monticello, Monon and Reynolds. Merle Pherson used to manage the stockyards in Monticello in the 1970s. "It was owned by the railroad," he said. "We tried to buy it from them, but they wouldn't sell it." At that time, they only had pigs and young cows to deal with. Trucks would come and haul them away. He remembers them taking the pigs all the way to Pennsylvania. Another person who worked there was Tom Geisler. He quit just before the yard closed in 1976.

The White County 4-H Fairgrounds is sort of a stockyard for one week in July when locals celebrate the annual fair that has been running since 1948. Animals are judged and awards are given to the youth who take care of them. Then at the end of the fair, some of the cattle and hogs are auctioned off to make money for the 4-H club and their owners.

TELEGRAPH OFFICES

Samuel Morris invented the telegraph, and it was used widely for communication beginning in the mid-1800s. At one time, about every large community had a telegraph office. Monticello had the Western Union Telegraph Office at 104 North Street until the 1920s. The role of the telegraph was replaced by the telephone, fax machine and internet in the twentieth century.

TRAIN STATIONS

At one time, about every town in White County had a train station where passengers would wait to board trains. Mail would also be delivered by the trains. Those stations began to dwindle in the 1950s, when passenger trains decided not to stop in these towns anymore. The stations became obsolete. Mail delivery was also eventually made by trucks, not trains.

The first railroad depot came to the county in 1853, when the Logansport, Peoria and Burlington Railroad completed a station in Monticello. However, the railroad didn't go to Logansport until a bridge was built over the Tippecanoe River in 1860. The station was later discontinued and torn down. The village of Monticello was incorporated as a town the same year. The following year, the town of Burnettsville was platted, as the railroad would pass through the area. A station was built there, too, and another was built in Idaville. Neither station still exists, but occasionally, a train still passes through the communities.

The construction of the Louisville, New Albany and Chicago Railroad through the county in 1854 made the villages of Brookston, Mudge's Station, New Bradford (later renamed Monon), Reynolds, Smithson and Wheeler possible. However, the railroad displaced the village of West Bedford, which was created east of New Bradford in 1837. Mudge's Station later became the village of Chalmers in 1873.

In 1859, the Pittsburgh, Chicago and St. Louis Railroad was completed through White County, bringing about the creation of Wolcott. The Logansport, Peoria and Burlington Railroad would come through the town as well but not until a railroad bridge was completed over the Tippecanoe River in 1860, making it possible for the Logansport, Peoria and Burlington Railroad pass to the east from Burnettsville and west through Monticello, Reynolds and Wolcott. The railroad also made the town of Idaville possible in 1860.

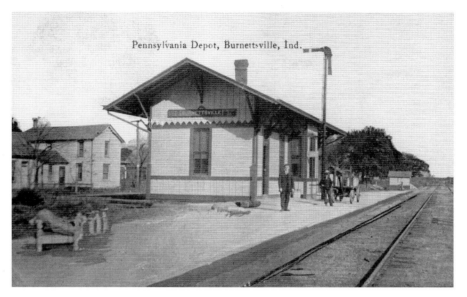

This Pennsylvania Railroad depot in Burnettsville was one of the first train stations in White County. *M.G. Callahan Company postcard.*

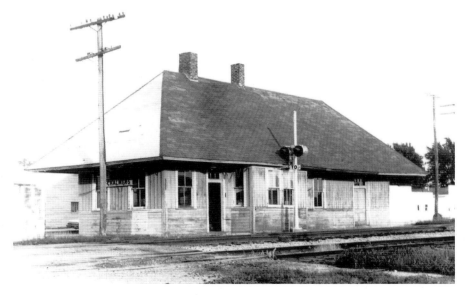

Chalmers once had this railroad station. The station was first established as Mudge's Station. *White County Historical Museum photograph.*

Farmers in the Wolcott and Seafield areas were glad when this occurred, as before 1860, they had to carry their goods all the way to Reynolds. This saved them trips of ten to fifteen miles in some cases over poor and winding roads. Wolcott's old railroad depot still stands south of the town, although it's no longer used for passengers.

The first railroad station in Monon was destroyed on September 18, 1951, when a Monon passenger train derailed and plowed into it. The diesel locomotive engineer Hub Dickerson was killed, and six passengers were injured. The train was southbound from Chicago to Louisville. "I saw the engines come around the curve," said switchman John Robinson in the *Journal and Courier*. "I heard a crash and saw the station crumble." A new station was built and remains as one of the only railroad stations still in use in White County—but not for passengers.

The last railroad station in Monticello was the Monon Railroad Station. Located on Railroad Street, the station was in use until Monon discontinued passenger service on September 30, 1967. The station was destroyed by a tornado on April 3, 1974.

VIDEO STORES

At one time during the late 1900s, every large community in the county had a video store or a place that rented out videotapes. They disappeared after the turn of the twenty-first century, and none are around anymore.

Back in the 1990s, Aardvark Video Repair Store was located on Rickey Road. At one time, a Movietime Video Store was located at 912 South Main Street, a building owned by Manihani Tech Petroleum Inc., according to

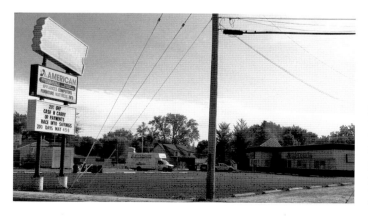

The Blockbuster sign is still evident on the post overlooking the old store, which is now rented to American Rental Home Furnishings. *W.C. Madden photograph.*

GONE BUT NOT FORGOTTEN

White County property records. The building was constructed in 1979. It was last used by Monical's Pizza, which closed in 2023.

One of the last video stores in Monticello was the Blockbuster on North Main Street, which was first the Video Stop Superstore. The building was first constructed in 1972 and contained a restaurant for a while. The building is now owned by Thayer and Sons Inc. and is rented to American Rental Home Furnishings. The Blockbuster survived until about 2015. A Papa John's Pizza store was housed inside the building, near the end of the video store, to try to attract more customers.

Videos were replaced by DVDs, and those are now available for rent from machines located in several locations in Monticello.

4

ALMOST LOST

Some local businesses have disappeared in recent years due to corporate giants taking business away from the small businessman. Some businesses have disappeared because their popularity has diminished some.

COMPUTER STORES

In the late twenty-first century, computer stores were all the rage, but they are fading fast. The county will have only two stores when this book goes to print—Dave's Computer World in Brookston and A1 Computers in Reynolds. However, there are other businesses in the county that repair computers.

The latest victim is Jimmerlane Computer Services, which announced in May 2023 that it would close its doors later in the year and sell all its equipment unless someone was willing to purchase the inventory and take it over. The owner, Jim "Jimmer" Black, a retired army veteran, decided to retire, as he had reached normal retirement age.

Black previously worked for Sugardog in Monticello from 2002 to until it closed in 2011. That's when he decided to start a computer business of his own. Sugardog began business in December 1999, when it launched an internet service. It was owned and run by Bob Bonnell and Steve Brown.

In the 1990s, S&S Computer Sales and Service was owned by Jerry Smith and was located on North Main Street in Monticello.

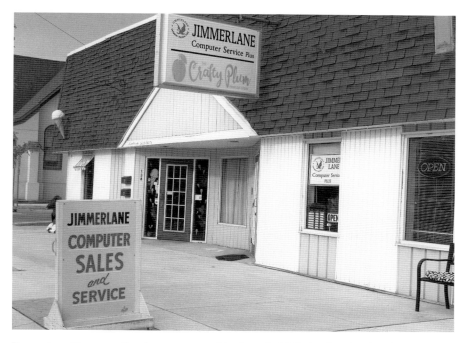

Jimmerlane Computer Services went out of business in 2023, leaving the city with no computer store except for Walmart. *W.C. Madden photograph.*

DRUGSTORES

Back more than one hundred years ago, just about every community in White County had a pharmacy, also known as a drugstore. The first drugstores were started and owned by doctors in the community. Now, there are only two drugstores remaining in White County: CVS and Walgreens in Monticello. However, grocery stores began having pharmacies within their stores. For example, Walmart and Kroger in Monticello have pharmacies.

The first druggist in the county may have been Dr. Sexton, who, in the 1850s, opened a store in Monticello. Then in the 1860s, Dr. Spencer and Son started up in Monticello. The first druggist in Monticello who wasn't a doctor may have been James E. Ballard. Then in the 1890s, Charles H. Casad opened a drugstore in the town at the corner of South Main and Broadway Streets. A drugstore was located at the spot for more than a century.

In the early 1900s, several new drugstores opened in the city, including Meeker's Drug Store, John McConnell's Drug Store, J.W. Meiser and W.S. Pierce Drugs.

The Monticello Drug Company first opened in the 1910s. It went into receivership in September 1928. The assets of the building and its contents were sold at auction. They were purchased by George D. Revington of Monon, who won the auction with a $3,100 bid. He got the stock, fixtures and furniture. He decided to move to Monticello to operate the store on North Main Street. He picked up the Rexall franchise and changed the name to the Rexall Store. Revington died in 1962 at his home on Lake Freeman. The location became the Main Street Mall Antiques in 1995. It was purchased in 2020 and remodeled the following year to become the home of Andrea Roller Photography and Events.

Another drugstore that came about in the 1910s was the F.E. & Bros. Bowman Druggist at 204 North Main Street in the city. In the 1930s, another drugstore was operating in the city—White Pharmacy at 115 North Main Street. In the 1940s, Walters Drug Store opened on South Main Street.

Then Hooks Drug Store, a statewide drugstore, came to the city and lasted until 1994, when the chain went defunct. The building was taken over by Revco. Finally, it became a CVS store, which moved to its current location on North Main Street in 1998.

Holder Pharmacy was located at 115 North Main Street in the 1960s.

During the middle of the 1900s, Hively's Pharmacy was popular at the corner of Broadway and Main Street. It was destroyed by fire in June 1970, but owner Ron Hively had it rebuilt. A murder occurred at the store

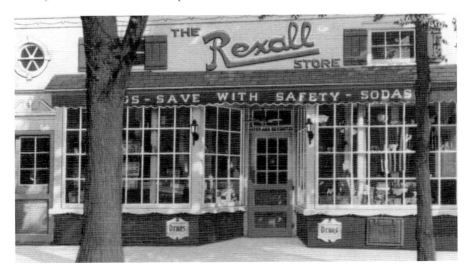

The Rexall Store lasted a long time in Monticello. The building now belongs to Andrea and Matthew Roller. *White County Historical Museum photograph.*

Hively's Drug Store was at the corner of South Main and Broadway Streets in Monticello in the late 1900s. *White County Historical Museum photograph.*

on the morning of June 17, 1974. Janitor Victor Tull came to work that day and was shot and killed by a burglar. "He pleaded for his life, and they shot him again and killed him," said Robert Fox, a detective sergeant for the Indiana State Police, according to the *History of Monticello*. Later, Jack Lee Laird pleaded guilty to second-degree murder and received a jail sentence of fifteen to twenty-five years in prison. Hively's was replaced in 1984 by Brooks Pharmacy, which was owned by Don Brooks. He later closed the store and went to work at Kroger. It was likely the last local drugstore in the city.

The Nordyke Drug Company was a staple in the Wolcott community for almost one hundred years. The store first came about when Robert Nordyke, a lifelong Wolcott resident, and his brother-in-law, Lewis Hinchman, bought the Hart Drugstore in 1913. Nordyke was born in White County on March 22, 1886. He had worked as the Wolcott/Reynolds postmaster and then became a clerk at the Hart's Bros. Drugstore before buying the business. In a 1930 census report, he is listed as being sixty-two years of age and living in Wolcott with the occupation of "proprietor in the drugstore industry." Interestingly, the census report states that Nordyke could read and write but said that he had not attended school. On January 3, 1934, Nordyke passed away, and the business went to his adult child Bliss Nordyke, who was born on

February 4, 1901. While under the care of Bliss Nordyke, the store was moved to the Masonic building in Wolcott, according to a September 22, 1939 *Herald Journal* article. The building was reported to have received an update. It was first built around 1900. The north room of the building was J.M. Winters Newsstand in 1939, and the other room had been recently vacated by the post office before the Nordyke Drug Store moved in. Bliss's son Robert "Bob" S. Nordyke, born on April 9, 1927, would eventually take over the business. The third-generation Nordyke was a Purdue graduate from the school of pharmacy in 1949 and served in the U.S. Navy as a pharmacist's mate, bringing to Wolcott an extensive background in pharmacy care to benefit the community. Bob Nordyke, along with his wife, Gloria, became a staple in the Wolcott community. The pharmacy also became a gathering place, where people could come in and step up to a soda counter to share in conversation and community engagement. In 2011, after fifty-six years, Nordyke Drug Store closed its doors after the passing of Bob Nordyke.

The last business to occupy the former location of the drugstore was Bell's Pizza, owned by Randy and Marsha Bell. The pizza parlor gave a nod to the past, leaving in place the old-time soda counter. It served pizza, sandwiches, salads and more, bringing back a place of gathering to the community. COVID-19 had an impact on rural businesses, and Bell's Pizza closed its doors due to the pandemic in 2021.

Other towns in the county also had drugstores at one time. In Brookston, the Wynkopp Drug Store, which was owned by S.M. Wynkopp, was in operation for quite some time. Then a Rexall Drug Store opened there in the 1930s. The last individually owned drugstore in the town was Holden Pharmacy, which went out of business in 1999, when its owner, John Holden, passed away.

The J.D. Brown Drug Store was in operation in Burnettsville in the early 1900s.

L.E. Miller had a drugstore in Idaville in the 1930s.

Boomershine Pharmacy operated in the 1920s and 1930s in Monon. It also had a soda fountain, which was common in pharmacies.

The Bush Drug Store was in operation in the early 1900s in Reynolds. It was owned by Dr. E.A. Bush. The Walters Pharmacy operated there in the 1920s. In the 1930s, the Haywood Drug Store and Watson Drug Store were in operation in the town.

Holden Pharmacy was in Brookston in the 1970s.

FUNERAL HOMES

Those who took care of the dead in the county were first known as undertakers. The term *funeral home* didn't come about until the 1900s. Undertakers and funeral homes were more common in the county in the 1900s than they are today. Some small towns in the county had funeral homes at one time, but now only three communities still have at least one.

The first undertaker in the county was Jonathan Harbolt, who practiced in Monticello in 1835. He was also a cabinet maker and made coffins. Michael Biederwolf was an undertaker in the 1880s in Monticello. He later merged with Meredith to become the Biederwolf and Meredith Funeral Directors at 111 South Main Street in the 1910s. In the early 1900s, Buckingham and Smoker Undertakers and Monticello Undertaking Company were in the business. O.A. Noel had an undertaking business in Burnettsville in the early 1900s.

Loran E. Miller started a funeral home in Idaville in 1920. In the 1920s, G.A. Stephan and Wilson Funeral Home and Freeman and Prevo Funeral Home came to Monticello. By the 1950s, Prevo and Sons and Miller Funeral Home were the only funeral homes in the city. Harry Voorhis came to town and joined up with Miller to start the Miller-Voorhis Funeral Home. Miller retired in 1986, and now it's the Miller-Roscka Funeral Home, owned by John Roscka.

Voorhis joined with Draper to become the Voorhis-Draper Funeral Home. Then Draper left, and Randy Springer came in 2007 and joined with Voorhis to form the Springer-Voorhis-Draper Funeral Home, which still exists today. Voorhis died in 2020.

Brookston and Monon have had funeral homes for a long time. In the 1930s, T.N. Brass Undertaker and Cottrell and Son Funeral Home were in operation in Brookston. Now, the town has the Hartzler-Clapper Funeral Home.

W.J. Hinke had a funeral home in Monon in the late 1920s. In the 1930s, Heltzel and Querry Funeral Home and Henry Funeral Home were located in the town. Today, the town has two funeral homes: Frazier Funeral Home and Cremation and the Clapper Funeral Home. The Frazier Funeral Home took over the previous location of Kellogg Funeral Home.

The Miller Funeral Home was first located in Idaville before it moved to Monticello in the 1920s. The Krueger and Heimlich Undertaking and Furniture Store was in Reynolds in the 1920s. The Holdridge and Foster Undertaking Parlor was in Wolcott in the 1930s.

Nowadays, there are still funeral homes in Brookston, Monon and Monticello.

GROCERY STORES

In the early 1900s, just about every community in White County had a mom-and-pop grocery store, and Monticello had several operating at one time. Now, there are three grocery stores in the county: Kroger, R&M and Walmart. Kroger and Walmart are in Monticello. R&M has stores in Brookston and Monticello. Some food is available at the dollar stores and service stations, which are more plentiful in the towns these days.

The first grocery store in the county may have been the one opened in the 1850s in Monticello by Robert Tinsdale. The entrepreneur first opened it on South Main Street and then moved it to the northwest corner of North Main and Washington Streets. Benjamin O. Spencer took over the Tinsdale location with an extensive line of groceries in 1877. Joseph Young opened a store a block north of Tinsdale in the 1860s. It lasted until Barnes Grocery took over the same location in the early 1900s. Sanford Johnsonbaugh also owned a grocery store that began in the 1800s and lasted into the twentieth century. Also in the early 1900s, the city had the City Grocery at the corner of Washington and Main Streets, Char. Davis Grocery at the corner of Main and Broadway Streets, Economy Grocer at 123 South Main Street and Frank R. Phillips Grocery at 115 East Broadway.

The Hackenburg and Mason Grocery came into existence in 1919 at 109 South Main Street in Monticello. The following year, it became the Mason and Meredith Grocery.

The 1920s saw the B.F. Reed Cash Grocery at 614 South Bluff Street in Monticello. It was later renamed the South Side Grocery. The old store building sat between some homes and was demolished a few years before the publication of this book. Another grocery store in operation in the Roaring Twenties was B.F. Reed Grocery at 120 South Main Street.

Jimmie's Market opened in the mid-1930s, and owner James Bush sold everything from green beans to watermelons. Reed's Grocery started operations in the 1930s at 119 South Main Street. A&P had a store in Monticello for quite some time, and it was last located on North Main Street in the 1970s.

Briney's IGA Store existed in the city until the 2000s. R&M took over the location and has been there ever since.

Wallman's Foods had north and south locations in the city into the 1990s. Now, the dollar store has north and south locations in the city, but they don't sell any fresh fruits or vegetables.

The Joseph Young Grocery Store was located at the corner of Marion and North Main Streets in the late 1800s. *White County Historical Museum photograph.*

The IGA store was located on the south side of Monticello in the mid-1900s. The same location is now used by R&M, and it is a much larger store than the IGA was. The IGA in Monticello was a franchise store, and the international corporation still has stores in forty-one countries.

Garden City Foods had a market at 1010 North Main Street in Monticello in the 1960s.

Sixbey's was a combination grocery and other things store in Monticello. It advertised "everything from soup to nuts." The store was damaged by the 1974 tornado but remained in business for some years after that.

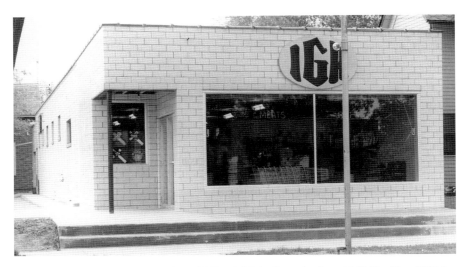

Above: This IGA store was located at 701 South Main Street in the mid-1900s. Now, R&M Food Mart operates from that location in a larger facility, which was built in 1974. *White County Historical Museum photograph.*

Opposite, top: The Wolcott Grocery store remains empty in the town. *Dorothy Salvo Benson photograph.*

Opposite, bottom: J.D. Rice had a grocery store in Norway in the early 1900s. *White County Historical Museum photograph.*

Most all of the other towns had grocery stores until the automobile came into existence. Then they slowly faded away as people began traveling farther distances more easily.

Burnettsville had a couple of grocery stores in the early 1900s. A.C. Hufford had a grocery store. Then L.N. Benjamin opened a store in 1916. The following year, J.J. Buchanan started a grocery store, and Hufford sold his store. R.J. Braden had a grocery store before he sold out to a Logansport grocer in 1919.

The Fred Friday Grocery Store lasted in Idaville for forty-five years. When Fred died, his son John ran the store for a decade.

Wolcott had two grocery stores in the 1930s: H&H Dry Goods and Groceries and the Staple Grocery. The last grocery the town had was the Wolcott Dairy and Grocery Store, and it lasted until about 2015. The empty building at 302 South Range Street is now vacant, but the faded words on the side identify the store was once used as a grocery. The Wolcott Grocery provided the town of Wolcott with a deli that sold fried chicken, fruits and vegetables and other food. Before the location was a grocery, it was the

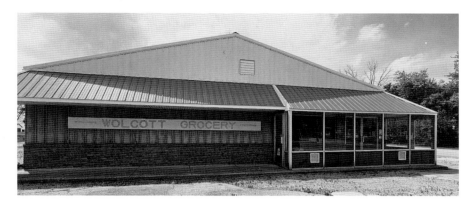

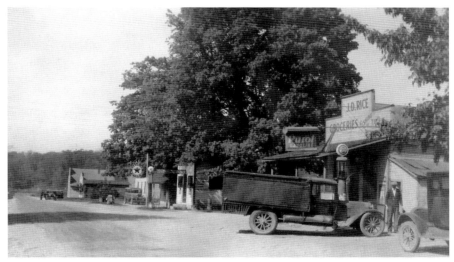

Marathon Service Station. In the 1940s, the service station provided gas, Miller tires, tire repair and lube. It was run by Bob Blume.

Brookston had two grocery stores in the 1920s: Chilton and Foust Grocery and Gerald Clevenger Grocery. The C.H. Dahling Grocery came about in the 1930s. Long's Food Market and IGA had stores in the town. Now, the only grocery in the town is R&M Food Market.

Frye and Ullery had a grocery store in Buffalo in 1914. Also in 1914, A.F. Galbreth had a grocery store in Burnettsville. In the 1930s, Burnettsville had two grocery stores: Don's Grocery and Personnett Grocery. The last time the town may have had a grocery was in the 1990s, when Heiny's Grocery was in operation.

Van's Cash Grocery operated in Chalmers in the 1930s.

J.D. Rice had a grocery store in Norway in the early 1900s.

H.G. Krueger and August Ruemler had grocery stores in Reynolds in the 1920s. In the 1930s, H.G. Krueger had a grocery store in the town.

The day of the small grocery store is gone.

HARDWARE STORES

Hardware stores have been around for a long time, and just about every community in White County had one at one time or another. But now, the county is down just two: Ace Hardware in Monticello and the Lowry Brothers Hardware and Farm in Reynolds.

In the early 1900s, Monticello had the E.R. Gardner Hardware and Implements Store at 223 North Main Street and the Richey and Pierson Hardware at 131 North Main Street, only a block apart. Smith was added to the Richey and Pierson Store in 1915, and then it was renamed Smith Hardware in 1920. Hall Hardware came to the city in the 1920s. S.J. Evans and Sons had a hardware store there, and Ed Gardner operated it for forty-three years.

Ace Hardware first had a store located at the corner of North Main and Washington Streets beginning in 1955. The McClintics owned the store and sold hardware as well as washers and dryers. The store went along just fine until a tornado damaged the top floor of the building in 1974. Business declined after that, and the store closed in 1980.

There was also Misenheimer's Hardware in Monticello in the 1960s. A Coast-to-Coast hardware store opened on North Main Street and operated for some years until it went bankrupt. That opened the door for Brad and Shari Moore to open another Ace Hardware, and they have been there ever since.

Brookston had hardware stores over the years, and the last was the Corner Hardware Store, which closed in 2022. Tedd Riley sold the building to Crasian Brewing Company. Corner Hardware opened on October 15, 2015, according to the Better Business Bureau. It was known as Brookston Hardware and Supply before then.

Burnettsville, Idaville, Monon and Wolcott all had hardware stores in the 1930s. Reynolds still has a hardware store.

HOSPITALS

The first hospital in the county was located in a home built in 1900 on North Bluff Street. It was founded in 1915 by Dr. Henry W. Greist and his wife and nurse, Molly Ward Butler. When the couple left for Alaska in 1920, they closed the hospital, and it never reopened. The house is now owned by Kenneth Felker.

Another hospital didn't open for quite some time. The White County Memorial Hospital first opened on April 16, 1956, at a cost of $520,000. It was a twenty-six-bed acute-care hospital. A new 18,097-square-foot addition came in 1963 at a cost of $238,000. Then in 1974, a $1.7 million two-story addition was built. Another 21,000-square-foot addition was made in 1996 at a cost of $5 million.

However, nine years later, the hospital was considered out-of-date, so Indiana University built a new ninety-thousand-square-foot hospital on Sixth Street for $25.5 million. IU White Memorial Hospital became the county's new facility and is still in use today.

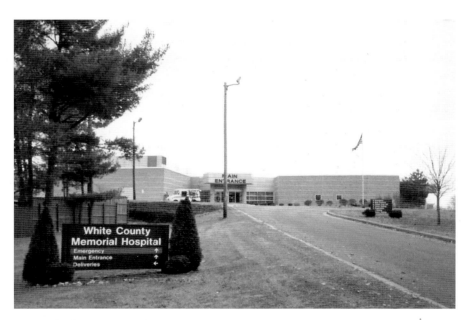

The White County Memorial Hospital first opened in 1956 and lasted into the twenty-first century. *W.C. Madden photograph.*

HOTELS

Hotels were much more numerous in the county in its early days; however, hotels then became motels or inns, and no place in the county calls itself a "hotel" anymore.

The first hotel in the county was built by Rowland Hughes when he came to Monticello in the 1830s. In 1866, David McCuaig came to the town and purchased an empty lot at the corner of North Main and Washington Streets. He built a one-story wood-frame building and created an inn with a restaurant and sleeping quarters. He and his wife, Janet, ran the place. A few years later, he decided to make the building larger by adding a second story. They called it the McCuaig House instead of a hotel to make it more attractive to businessmen. After thirty years of business, they were able to retire and lease their hotel to someone else. The building was moved in 1901 and continued as the McCuaig Hotel for a while longer.

The St. Elmo Hotel on North Illinois Street, just south of the Panhandle Railroad, came about in 1887, when L.S. Engle purchased the Anderson house, which was built in 1846, and renamed it. It provided rooms for those riding on the Pennsylvania Railroad. The hotel eventually became a boardinghouse. Then it was purchased by the Lincoln School after it was damaged by a fire in August 1905. The school used it until repairs could be made.

C.M. Horner built a two-story structure at the corner of Market and Fourth Streets in the 1870s in Monon. The first floor was occupied by the Monon State Bank, and the Arlington Hotel was on the second floor. The hotel was remodeled in 1921. The State Bank was a victim of the stock market crash in 1929. The hotel was then a victim of the Great Depression.

In 1880, Monticello's famous brick builder Ira Kingsbury built a three-story building at the corner of Harrison and Main Streets. Then, in 1899, came William N. Forbis, who turned it into a hotel. He died in 1908 and left it to his relatives, who continued to run it until the 1960s, when it was no longer profitable. The historic building was put up for auction, and Floyd Hall purchased it for $25,500. Then he spent another $120,000 redesigning the three-story building to become a four-story structure. What he did was take the hotel's first floor, which had eighteen-foot ceilings, and convert it into two floors. Hall also added bathrooms upstairs. It became an apartment building, with businesses using the first floor.

The Perrigo Hotel in Monticello was originally called the Carson Home, and it was built with lumber from the Chicago's World Fair in 1893. It lasted

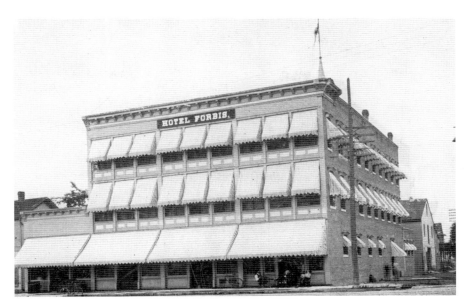

The Forbis Hotel first came about in the early 1900s and lasted until the 1960s. *Imogene Clerget photograph.*

until 1957, when it was razed to make room for the State and Savings Bank in the 100 West Washington Street block.

The Cottage Hotel was built in Reynolds in the late 1800s. Levi Swisher was the owner. The hotel was torn down in the 1960s to make room for Solly's Restaurant. The Maple Hotel was also located there in the 1920s.

LUMBER STORES

Lumber stores have been around for a long time, and just about every community in White County had one at one time or another. But now, the county is down to one lumber store with two locations: Dye Lumber in Monticello and Monon. Dye was originally founded by George D. and Emma Dye in the early 1900s in Wolcott. Then their son Russell opened Dye Lumber and Coal in Monon in 1924. Russell opened a Monticello location in 1946 on South Illinois Street. Now, the Monticello store is located on West Broadway and is run by Russell's grandson Art Dragoo. The original Wolcott store closed in June 2015 after one hundred years of service to the community.

One of the first lumber companies in the county was in Brookston. The Bordner Lumber Company was founded by Isreal Bordner in 1867. It lasted nearly a century, but after ninety years in business, it closed in 1957.

The first lumber companies in Monticello started in the 1870s. S.B.&A. Wright manufactured lumber in its sawmill. Other competitors came along, including Biederwolf Lumber and Coal and Turner and McCollum Lumber, which was located on North Illinois Street. Turner and McCollum was sold to Curtis D. Meeker in 1888. In 1900, Meeker sold half of his interest to Jones Brearley, who renamed it Monticello Lumber Company. Brearley sold the store to Clyde H. Fisher and E.H. Condon in 1949. Clyde's son Beatty would eventually run the store and ended up owning it. The store lasted into the twenty-first century before closing. The place became a thrift store run much like a Goodwill Store and is now known as Lirio.

George Biederwolf sold his lumber company in 1917, and his son Fred purchased the coal business. Then Fred added ice, and it became the Biederwolf Coal and Ice Company.

Curtis D. Meeker also opened the White County Lumber Company in Monticello. He sold it in 1929 to the Stultz Lumber Company, owned by Arlie and Omer Stultz. Located on South Illinois Street, it later became the Vol Tobel Lumber Company in 1955. The building is now occupied by the Knights of Columbus.

Other towns in the county also had lumber stores at one time or another, including Burnettsville, Chalmers, Monon, Reynolds and Wolcott.

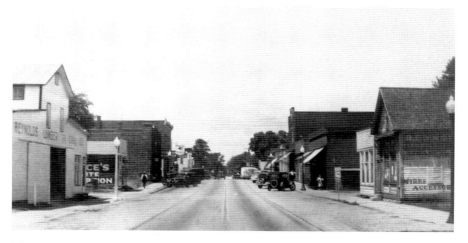

The Reynolds Lumber and Coal business (*left*) was located near the railroad tracks. *White County Historical Museum photograph.*

MEAT MARKETS

Meat markets have all but disappeared in the county, but one remains, Monon Meats in the town of Monon. Meat markets began appearing in the early 1900s.

The Meat Market was opened in 1909 by Christopher Cain in Monticello. He later named it after himself. It was located at 232 North Main Street. He retired in 1939, and his son Ben took over the operation. The Fraser and Jacks Meat Market opened at 103 West Broadway in the 1910s. The Country Meat Market opened in the 1920s at 119 West Washington Street.

Other towns in the county also had meat markets at one time. The Chilton Meat Market was in Brookston in the 1920s. In 1915, Clark Mertz had a meat market in Burnettsville that lasted into the 1930s. Merle Van Meter had a meat market in Idaville in the 1920s and 1930s. Monon had the Consumers Meat Market in the 1920s. Also in the 1920s, the town had the Kern Meat Market. In the 1930s, the Landis Meat Market started operations. Reynolds had the Minnicus Meat Market in the 1920s, and it was owned by George Minnicus. Wolcott had the Hollett Meat Market in the 1930s. The Heinold Hog Market was in Chalmers in the 1970s.

NEWSPAPERS AND MAGAZINES

Many newspapers have come and gone since they began publishing in the county in 1850. In the 1800s, just about every community had a newspaper. Some were tied to a political party, and some even had the political party in their name. At the end of 2022, there were only three weekly newspapers remaining in White County: *Monticello Herald Journal*, *News and Review* and *Wolcott Enterprise*.

Brookston

A paper called the *Brookston Gazette* was published in 1899 by George H. Healey. It was later absorbed by the *Brookston Reporter*, which was founded on April 3, 1873, by M.H. Ingram. The paper was independent in its politics. It was published until 1985.

LOST WHITE COUNTY, INDIANA

The *Brookston Magnet* existed for less than a year, as S.M. Burns first published it in November 1887. The plant was sold the following year, and it moved to Sheldon, Illinois.

The *Brookston Prairie Review* started in 1886 and lasted until 1992. It was then absorbed by the *News and Review*.

The *Brookston News* lasted only six months, from April 17, 1953, to September 23, 1953.

The *Community Sun* was published in the 1980s and went out of business in 1991.

Buffalo

The *Buffalo Republic* was published only in 1850.

Burnettsville

The *Burnettsville Enterprise* was the first paper in the town and was established in 1890 by J.E. Sutton. The paper was printed in Logansport and failed in 1894.

The *Burnettsville Dispatch* was first printed on April 20, 1900, by Sylvester W. Rizer. He sold it to Harriett Fuller in 1902, and then it went out of business.

The *Burnettsville News* was first printed in the town on November 21, 1907, by J. Rolland Doan. The paper went through several owners and lasted until December 1943.

Chalmers

The first newspaper in Chalmers was the *Chalmers Bulletin*, first printed in 1890 by Isaac Parsons. It stopped being published in 1895.

The *Chalmers Ledger* first appeared in November 1892, printed by Mr. Patterson. The paper went through a couple of hands until it landed in the lap of Healey, who published it for a couple of months in 1900 before suspending it and combining it with his Brookston paper. The paper was replaced by the *Chalmers Dispatch*, founded in April 1900 by Wilbur A. Walts. The paper changed hands several times. In 1912, a paper called the

Progressive was published by the Dispatch office, but it was suspended soon after the election. The *Dispatch* lasted until 1915.

The Chalmers Community Council published a paper called the *Chalmers News* from July 20, 1964, until 1973.

Idaville

The first paper in the small town was the *Idaville Independent*, first printed in 1884 by George W. Lucy and Mell F. Pilling. It changed ownership, and the name was changed to the *Idaville Observer* on June 9, 1886. The paper folded in 1943.

The *Idaville Enterprise* was established in 1925 by G.D.E.L. Hays, who sold it to B.F. Reafsnyder in September 1926. It ceased publication in 1927.

Monon

The first paper in Monon was the *Monon Independent*, published by Edward Massinan in November 1883, but it lasted less than a year and was last published on October 10, 1884.

The *Monon Dispatch* was first published by Stokes and Martin in September 1884. Its name was changed to the *Monon Leader* in January 1887. Owners Charles E. Cook and Dr. John T. Reed sold it in January 1889, and it moved to Ladoga, Indiana.

At the beginning of the new century, the *Monon Times* was published by John M. Winkley. It was succeeded by the *Monon News*, which was owned by Isaac Parsons, in April 1902. The paper went through many hands and lasted until the 1990s. It was absorbed by the *News and Review*.

The *Bedford Daily Mail Newspaper* was first published in November 1906 and lasted for a short time.

Monticello

The *Prairie Chieftain* was first published on July 17, 1850, by owners John K. Lovejoy and Abram V. Reed. The four-page Democratic paper was published in the old courthouse located at 209 South Main Street. An old handpress was used to print the "all-rag" paper. It published the story of the

first murder trial in White County in its November 4, 1850 issue. The last issue of the newspaper came on July 18, 1857.

In 1855 and 1856, four other newspapers existed: *Political Frame, Monticello Tribune, Monticello Republican* and *Monticello Union*. None of these papers lasted very long.

The Republican Party had grown strong in the county, so a paper affiliated with it began on May 12, 1859. Brothers James and Benjamin Spencer started the *Monticello Spectator* on May 12, 1859. It lasted only until January 1862, when its new owner, Milton M. Sill, decided to change its name to the *Monticello Herald*. The newspaper lasted until December 1942. Then it became the *Monticello Herald Journal* and was published six days a week. In 2018, it became a biweekly, and then it became a weekly in 2022.

The *Monticello Weekly Democrat* was first published on March 31, 1864. Its last issue was published on October 8, 1880.

The *Monticello National* was a weekly first published in 1878 by Jacob Clay Smith. Its name was changed to the *People's Advocate* by W.I. Harbert in 1892. Then it was changed back to *National* and lasted until 1905.

In July 1881, Cleveland J. Reynolds started a Democratic paper called the *Times*. The paper lasted only until January 1882, when Reynolds left town and was never seen again.

The *Alliance Chronicle* was published by Jacob C. Smith in the early 1890s and was supported by the Populist Party for a few years.

The *Monticello Times* was established on September 16, 1892, by Isaac Parsons, but he soon ended it in 1893.

The *Monticello Weekly Press* was started in April 1894 by Cary M. Reynolds and Harry T. Bott. The weekly was independent in its politics. It was sold to W.J. Huff in February 1895. The last issue was printed in September 1897.

The *Daily Journal* was started by Reynolds and Bott on March 7, 1896. It started as a morning daily but soon changed to an evening edition. Its name was eventually changed to the *Monticello Evening Journal* on February 26, 1913. The final issue of the paper came on August 16, 1929. The following day, it was renamed the *Monticello Journal*, which lasted until December 31, 1938.

In December 1912, the Democrat-Journal-Observer Company was incorporated and took on the *Idaville Observer*, the *Reynolds Journal* and the *Monticello Evening Journal*, which was first published on February 26, 1913.

The *Monticello Sun* was published from May 30, 1990, to July 17, 1991. It was replaced by the *Sun-Journal* and published from July 24, 1991, to November 3, 1993.

Monticello magazine was the only magazine published in White County. This was the cover of its last issue in the spring of 2022. *W.C. Madden photograph.*

The county has had only one magazine in its history. Author W.C. Madden started *Monticello* magazine in 2013. He sold the magazine to Kankakee Valley Publishing in 2015, but he remained as its editor until the publication ceased in the spring of 2022.

Reynolds

The *Broom*, a paper of the Greenback Party, was first started in Monticello in the spring of 1878, but it moved to Reynolds in 1892. Then it became a paper of the People's Party. However, it soon died.

The *Reynolds Sun*, begun in 1899 by L.M. Crom, also had a brief career.

The *Reynolds Journal* was started in March 1910, but it lasted only four years, and its last issue was printed on October 24, 1913.

Wolcott

The *Wolcott Banner* was established by the Van Cleave brothers in 1891 and lasted only about six months.

White County

The *White County Register* came out in the 1850s as well. Richard T. Parker was its publisher, and Benjamin F. Tilden was its editor. When Tilden died in the fall of 1854, the paper died as well.

Early in November 1857, the *White County Jacksonian* began being published. It was owned by John H. Scott, who came from Logansport. The *Jacksonian* put "Democratic" in large type below its heading, so its political affiliation was obvious. Scott died a year later, and the newspaper went with him. But before he died, he renamed the paper the *White County Democrat*. James W. McEwen from Pennsylvania bought the plant of the *Jacksonian* and continued publishing the *Democrat*. In 1866, he partnered with N.C.A. Rayhouser and changed the paper's name to the *Constitutionalist* until January 1877. A new firm took possession of the *White County Democrat* and moved it to Reynolds. It also changed the name of the paper to the *Monticello Democrat*, and the first issue was printed on February 3, 1877. Jasper H. Keyes took possession of the paper on September 26, 1879. The office was damaged by a fire on March 20, 1881, and the county was without a Democratic paper for a while. The county was without a Democratic paper, but that didn't last long, as a new *White County Democrat* first appeared on June 16, 1882. It was published by Harry P. Owens and William E. Uhl, both lawyers. This newspaper lasted for a long time and finally died out in December 1955. The *White County Democrat* was changed to the *White County Times* on January 5, 1956, and it continued until March 31, 1966.

In 1866, McEwen joined N.C.A. Rayhouser to form a partnership and renamed the *White County Democrat* the *Constitutionalist*. The paper continued until McEwen decided to retire in January 1877. The plant was sold and then moved to Rensselaer.

The Reynolds Publishing Company first published the *White County Banner* on February 24, 1871. The paper was sold to J.E. Dunham in 1872, and he changed its name to the Central Clarion. The new name lasted until 1876, when it became the *White County Register*. It was suspended in 1878, after the law was changed to require a sheriff's sale to be published in the newspaper nearest the land to be sold.

The *White County Republican* was started in Monticello in December 1899 by Ashbel P. Reynolds. It lasted less than a year.

In the spring of 1914, the *White County Citizen* was first published as a weekly for the Progressive Party. The first issue was printed on May 29. After the November election, it was changed to a semiweekly and even a daily for

three days in December, but it was suspended on the first day of January the following year.

The *White County Beacon* was started as an independent paper in 1938 by C.O. Blackery. Robert E. and Harriet McGlynn took it over in 1967, and it lasted into the 1970s.

One newspaper, *Farm News of White County*, was published in Indianapolis by Farm Publications Inc. What years it was published in are unknown, but the White County Historical Museum has a copy of a 1946 issue.

ONE-WAY STREETS

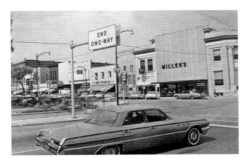

This sign on Broadway Street indicates the end of the one-way street in Monticello during the 1960s. *White County Historical Museum photograph.*

The only community in White County to have one-way streets is Monticello. They first came about in the mid-1900s, when the city decided to make Broadway a one-way street going eastbound from Railroad Street to Main Street. At the same time, North Main Street was one way going north from Broadway to the point where it met Illinois Street.

Sometime after a tornado, the city decided to make Main Street a one-way street from Harrison Street north to where it meets Illinois Street. It also made Illinois Street a one-way street going south from where it meets North Main Street to Harrison Street, and it remains that way today. Motorists are sometimes surprised that the city has one-way streets and end up going the wrong way.

TELEPHONE COMPANIES

Around one hundred years ago, just about every town in White County had its own telephone company. Some of the companies were located in homes. Telephone service was quite different a century ago. You had the choice of three different lines: single, two-party or four-party. The more lines, the cheaper the price. When you made a call, you had some options,

like person-to-person calls, long-distance calls and station-to-station calls. The telephone companies had rules. They wanted the caller to limit their calls to five minutes. They advised against calling during electrical storms. United Telephone had this rule: "The use of profane or indecent language over the telephone is unlawful." It also told callers not to listen to conversations over party lines, as it was prohibited. They could remove phone service for violators.

The Monticello Telephone Company began regular service in November 1895 with sixty-five subscribers. A long-distance call cost twenty-five cents, but that was considered a lot of money, as a loaf of bread cost only three cents at the time. The company grew, and by 1926, it had almost one thousand subscribers who made about one hundred thousand local calls and seventeen thousand toll calls per month.

Other towns followed Monticello. Brookston was controlled by the Prairie Telephone Company. There was also the Chalmers Telephone Company, Idaville Co-operative Telephone Company, Monon Telephone Company, Monticello Telephone Company and Reynolds Telephone Company.

C.L. Brown began United Telephone Company in 1911 and started buying up independent telephone companies. His company started doing business in White County in the 1920s, and some town telephone companies were bought up. United bought out the Monticello Telephone Company in 1931. T.A. Hanway was the new owner. In August 1931, United selected Monticello as its headquarters for Indiana. A total of forty-six Indiana town telephone companies called Monticello headquarters. Also in the 1930s, Burnettsville and Chalmers were bought out by United. The Great Depression in the 1930s resulted in a loss of customers, as they could not afford to pay their bills.

In December 1972, United Telephone moved out of the building on Court Street and moved into a new building on Illinois Street. It was a good thing they did, because the tornado of April 3, 1974, damaged the Court Street building, and it was torn down. The tornado knocked out telephone service for a while and blew away the company's microwave antenna. In the 1980s, the company was bought by Sprint.

Nowadays, there is only one independent telephone company still in the county, the Monon Telephone Company, founded in August 1900. James and Elizabeth Graves were the original owners of the company. Less than one thousand independent telephone companies still exist in the United States.

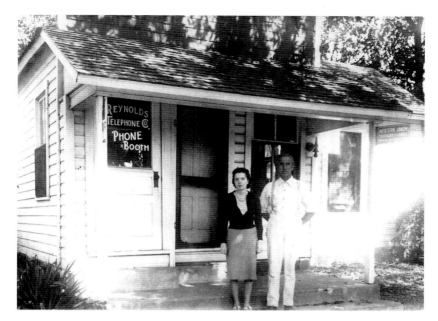

Standing outside the Reynolds Telephone Phone Booth are Albert and Mabelle Geier, the owners. It was located behind what is now a service station at Reynolds. *Honeycreek Township photograph.*

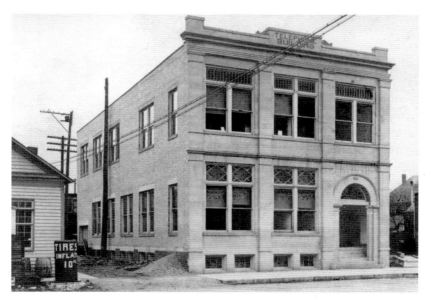

The Monticello Telephone Company owned this building on Court Street until it moved out in December 1972. The building was heavily damaged by the 1974 tornado and was later demolished. *Rod Pool photograph.*

5

SCHOOLS

The first schools built in the county were one-room schoolhouses. The first one-room schoolhouse in White County was built the same year the county came into being in 1834. The building was located on the banks of Big Creek in Big Creek Township. The log schoolhouse comprised 108 square feet. A log was omitted from the south wall to admit light. A string passed through the door above the latch and served to raise it from the outside. Rough-hewn timbers were used to make the puncheon desks and seats.

The following year, the first school was built in Monticello. The framed schoolhouse was much larger at six hundred square feet.

One-room schoolhouses started popping up all over the county. They were located just a couple of miles from each other so students could walk to and from the schools.

The 1840 census revealed that only one in seven Hoosiers were literate, and about 18 percent of school-aged children in the state attended school on a regular basis. This changed when the School Law of 1852 was passed and made school a compulsory part of Indiana society.

The first graded schoolhouse in Monticello came about in 1859. The Union Township trustees leased a feed stable to house the school. It lasted for a decade before a more substantial structure was erected.

In Burnettsville, the Farmington Male and Female Seminary was founded in 1852 by Isaac Mahurin. Located at 907 South West Street, the school was so popular that it received pupils from surrounding communities, such as Logansport, Lafayette, Peru and Delphi.

Schools

The Tile Mill School was built in 1898. It is located on Indiana State Road 16 in Monon Township. When it was last used as a school is unknown, but it was used as a house and then for storage. It's now abandoned and in decay. *W.C. Madden photograph*.

The first graded school in Monticello was located behind the Forbis Hotel on Harrison Street. *Photograph from* A Standard History of White County.

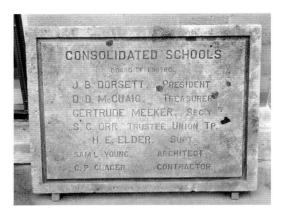

This plaque shows the officers who were responsible for the consolidation of schools that took place in the 1920s in Union Township. It now sits at the White County Historical Museum. *W.C. Madden photograph.*

Then in 1858, a normal school was established in Burnettsville, the first in Indiana and the fifth in the United States. Its number of students increased, so the Christian church in town was used for schooling as well. The school lasted a couple of more years before closing, as its founder, Mr. Baldwin, had resigned.

In 1921, the Indiana General Assembly enacted the Greencastle Law of Consolidation. At this time, 107 one-room schoolhouses existed in the county, and this resulted in their demise.

The Indiana School Reorganization Act of 1959 resulted in a huge transformation of the school system in the state. The effort resulted in the number of school corporations in White County being consolidated from ten to four. It spelled the end of the high schools in smaller towns and hurt their economies as a result. By 1963, the number of high schools had dropped from 969 to 506. White County dropped from having 10 high schools down to 4: Frontier in Chalmers, North White in Monon, Tri-County in Wolcott and Twin Lakes in Monticello.

The following are the ten high schools that no longer exist because of the consolidation.

BROOKSTON HIGH SCHOOL

The Brookston Academy, which was like a high school, was built in 1867. The two-story school was sixty feet by eighty feet and had two classrooms on both floors. Dr. John Medaris was its teacher. In 1873, with a debt of $7,000, the academy was sold to Prairie Township, which remodeled it to become the first Town Commissioned High School. W.F. Neel became the

superintendent, and Lida Moody was the principal. The boys had manual training in their curriculum, while the girls had sewing. By 1915, the school had an average attendance of seventy-five.

A total of thirty-five students graduated from Brookston High School in 1963, the school's last year. The valedictorian was Norman Weiderhaft, and John Hague was the salutatorian.

The Brookston sports teams were called the Bombers. The name was likely adopted after World War II, as bombers were used during the war.

Frontier High School was then created in Brookston, and students from Brookston, Round Grove and Chalmers High Schools were transferred there. It was one of the last consolidations in the county and occurred in 1965.

BUFFALO HIGH SCHOOL

Buffalo High School was first built in 1929. The first class to graduate in 1933 had a dozen students.

The school had an assembly room where all the students would go when they weren't in their classroom. The school had only six classrooms: four upstairs and two downstairs. "You could have several different classes in each room," explained Fay "Meme" (Capper) Crowder, who graduated in 1951 from the school. "You knew everyone in the whole school, because they were all in the same [assembly] room."

Crowder took English, algebra, history, music and home economics. The school had one stove in the home economics room, and it was a music room when it wasn't being used for home economics.

The gymnasium had bleachers on one side, and they were only four rows high. The gym was sometimes transformed into an auditorium. "When we had plays, we had to close off one end of the gymnasium," Crowder said.

The school had a basketball team, a baseball team, a cross-country team and a track team. It didn't have enough boys for a football team. All the boys were needed for the basketball team, except one boy who was a cheerleader. "There wasn't anything for girls at that time," Crowder said. The girls didn't have any sports teams, but they did have a cheerleading squad, and Crowder became a cheerleader herself. One year, the cheerleaders finished in third place in the county of ten high schools. "That was pretty good."

The school also had a band. One student went on to become a doctor, Crowder said. The school had a playground, but there were sand burrs that prevented the students from having much fun, Crowder explained.

The last class to graduate from Buffalo High School graduated in 1963 and had fifteen students. The valedictorian was Sharon Lee Coonrod. Students were transferred the next school year to North White High School in Monon.

BURNETTSVILLE HIGH SCHOOL

This plaque shows when the construction of the gym at Burnettsville High School was completed. The old gym is still in use today. *W.C. Madden photograph.*

In 1872, a new school was built in town. The Burnettsville High School system was formed in 1886. Then in 1903, the construction of a two-story red brick schoolhouse began at the corner of Fifth and Logan Streets. Burnettsville High School had a large assembly room for all students to gather in, as well as a laboratory.

In January 1927, the construction of a new addition, which contained a new gymnasium, four classrooms and a heating plant for the entire school, began. The addition was dedicated in October 1938.

The school's sports teams were known as the Bees.

Fifteen students graduated in the last class at Burnettsville High School in 1963. The valedictorian of the school was Janice Mae Carlson, while Jean Elaine Busler was the salutatorian. The next school year, students were transferred to Twin Lakes School District in Monticello.

CHALMERS HIGH SCHOOL

Chalmers High School was built in 1911. The school was closed in 1965. Its sports teams were known as the Cardinals. Chalmers students ended up being transferred to Frontier High School, which was built in the community. The old school building was torn down in 1978.

IDAVILLE HIGH SCHOOL

Idaville High School was first founded in 1898. Class sessions were held in Woodmen's Hall. About fifteen students enrolled in the school's first year, and Jay Mertz was the only teacher. More interest came from the community for the second year of the school. U.R. Young was in charge at the time.

For the school's third year, an additional room was provided, and the high school was transferred to larger and better-equipped quarters, a large brick building. O.C. Black was employed as the principal. A total of four students graduated in the class of 1901, as the school was only three years old.

In 1910, the school building was rebuilt, and commodious quarters were provided for the high school. Laboratories were provided for the botany and physics classes.

The first yearbook was published by the senior class in 1911. A total of nine students graduated in 1911. Classes included physics, mathematics, history, Latin, English and botany. The school had an orchestra with eight students and the Girl's Sextette. The school had a basketball team and track team, and they were known as the Green Streaks.

Back then, the school started classes on September 25 and ended on May 16. A vacation was given for Thanksgiving and Christmas.

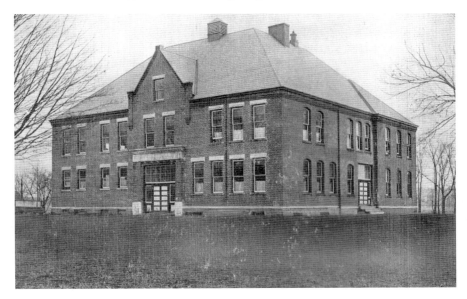

Idaville High School was built in 1910. It burned down two years later, and another school had to be built. *Idaville High School, 1911 yearbook photograph.*

In 1912, the school burned down, and another school was built two years later to replace it.

Michael Hirt attended the school in his first two years of high school before the consolidation of schools in 1963. He said the school taught grades one through twelve, as there was no kindergarten. The first and second graders were taught in the same room. Third and fourth graders were also taught in the same room, as were the fifth and sixth graders. Those classrooms were located on the first floor.

Seventh through twelfth graders were taught on the second floor. The second floor also had a library, music room and chemistry room. English and math were taught in the same room but at different times.

The bathrooms and gym were located in the basement, so the gym had a low ceiling and no bleachers. "We could never have games there," explained Michael. The school's teams would play their home games at either Buffalo High School or Burnettsville High School.

"We ate lunch in our rooms, as there was no cafeteria," said Michael. He lived a "stone's throw" from the school. "Most of all the kids were from farms."

The last class from Idaville High School graduated in 1963 with twelve graduates. Thomas W. Lontz was the valedictorian, while James Harold Andrews was the salutatorian. The following year, Idaville students went to the Twin Lakes schools in Monticello.

The high school building was then used as a grade school by Twin Lakes School Corporation until Eastlawn Elementary School was built in 1976.

After a furniture factory in the town burned down, the old school building was used to house the business for a while, according to Hirt. Then it became an auction house for a short time. Finally, it was torn down in the late 1970s.

MONON HIGH SCHOOL

High school classes in Monon were first held in the Opera House and the Arlington Hotel. The first class to graduate from high school in Monon was the class of 1900, and the first high school was built the next year.

A new high school was then constructed in 1926. The old high school became an elementary school. The two schools were located along Indiana 421 at its intersection with Indiana 16.

"There was a tunnel connecting the two schools," said Phyllis "Fizzy" Cooley, a 1950 graduate of the school. She had thirty-six students in her graduating class.

Schools

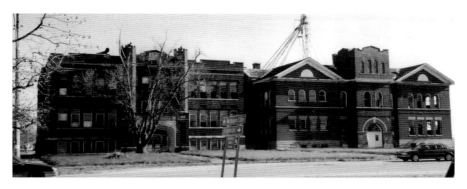

The building on the right was constructed as the Monon High School and Grade School in 1902. The building on the left was constructed as the high school in 1926. Both schools were demolished in 1998. *Phyllis Cooley photograph.*

The high school had a large assembly room where students started each day and attendance was taken. The gymnasium was located in the center of the school where students entered through the front door, Cooley recalled. It had bleachers and a balcony. "The older people sat in the balcony, and the younger people sat in the bleachers," the ninety-year-old woman said. The gym had a stage on one side as well.

The school held physical education classes in the gym, too. Cooley didn't like the gym clothes and said they were "ugly royal blue one-piece gym suits."

The school had a home economics classroom. "We had a lot of sewing machines," said Cooley. The home economics students helped serve lunch and make decorations for the school's prom, which was held in the gym. The other classrooms were large, and about thirty students could fit in each.

The school also had a large cafeteria. The cafeteria was also used for dances. "My skirt flew up, so they took me off the floor," Cooley recalled.

The school had a basketball team but no football team. The teams were called the Railroaders. During halftime, someone would lead a large-scale train on the court. Some of the boys also acted as yell leaders during the games. The school had a large marching band that would provide entertainment.

Cooley said that some students would sometimes break into the school by opening windows under the bleachers and eat the celery and carrots they had soaking in water in the kitchen. Students were not allowed to chew gum in school.

The student newspaper was appropriately called *Cinders* to keep with the railroad theme of the school. The yearbooks were called the *Mononitor*.

The last graduating class at Monon High School in 1963 had thirty-seven students. The valedictorian was Cherryl Gritzbaugh, and the salutatorian was Marcia Burbage. North White High School was built nearby, so students didn't have to go very far to attend their new school the following year.

The old high school was demolished in 1998.

MONTICELLO HIGH SCHOOL

The first high school in Monticello was erected in 1869 at the corner of West Broadway and South First Street. It was part of the grade school system. A fire destroyed the building in August 1905.

Another larger building was erected for the high school, yet it also accommodated lower grades for some time. The West Grade Building contained seven large classrooms on its first floor. The second floor had an assembly room, library, reception room and three offices, including an office for the superintendent. The third floor contained the physical,

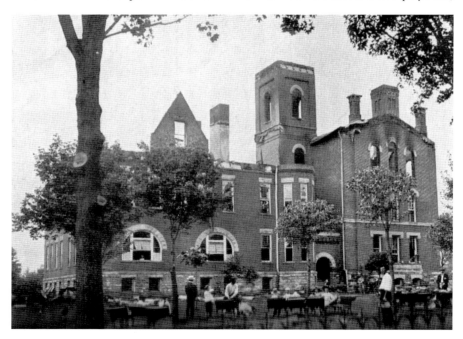

Monticello High School was erected in 1869 and destroyed by a fire in August 1905. *Photograph from* A Standard History of White County.

SCHOOLS

chemical and biological laboratories. It also had a lecture room. The basement contained a steam heater that provided steam to the radiators in each room. It also had playrooms for bad weather and luncheon rooms. Each floor had toilet facilities.

The high school building was enlarged in the 1920s to handle the school's increase in population. The building was used as a high school until Roosevelt High School was built in March 1938.

Seventy-six students graduated in the last class from Monticello High School in 1963. The valedictorian was Mary Ann Pierce, and the salutatorian was Charlotte Ann Hanna.

The old high school was renamed the Lincoln Building and was used as a junior high school until 1969. The students were then sent to Roosevelt High School, which became a junior high and has remained so until the publication of this book. The Twin Lakes School Corporation built a new high school a block away in 1969, and it is still used today.

The Lincoln Building was damaged by the tornado of April 3, 1974, and was torn down after that. The area was turned into a park until the Monticello-Union Township Library was built at the site in 1992.

When school consolidation occurred in 1963, many schools in the county had to close their doors forever. Twin Lakes became the largest school corporation in the county. It had 221 children entering the first grade in 1964, so it had seven elementary schools to handle the load: Adams, Burnettsville, Idaville, Yeoman and three in Monticello, Meadowlawn, Oaklawn and Woodlawn.

REYNOLDS HIGH SCHOOL

The Reynolds School was built in 1914 and later became a high school. The school had ten rooms. A gymnasium was added in 1940, and that portion remains today.

The Reynolds School contained classes from first through twelfth grade. The high school had an assembly room where school started each day and roll call was made. It also had classes in English, history, home economics, math, science and social studies.

Alene Clerget McKinley attended the school and graduated in 1951. She had only ten students in her class, and she finished second in her class, so she was the salutatorian. She remembers working in the cafeteria there. "You got a free meal if you worked in the cafeteria," she said.

73

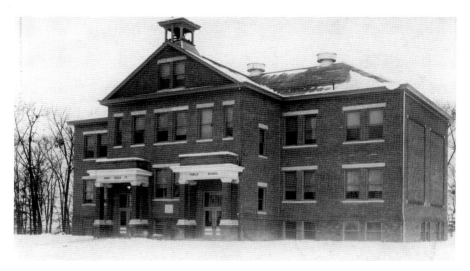

The Reynolds school contained ten rooms and was built in 1914. *Larry Hartzler photograph.*

At that time, the school had only a men's basketball team, but McKinley said a football team was later added. The basketball team was known as the Rangers, and it won the county championship.

"We got to miss school for the whole day," recalled McKinley, who was a farm girl at the time. They were dismissed after roll was taken, so they had all day to kill; however, there wasn't much to do in Reynolds. McKinley ended up going to the Green Gables Restaurant and then the pool hall. She played one of the best boy pool players and beat him. "He was so upset."

McKinley remembered that the history class got to witness the trial of a boy who had attended the school but had dropped out. The next day after roll call, she skipped out with some boys, and they drove to Monticello to see the end of the trial. The judge appeared and told them, "Your principal would like you to come back to school."

They went back to school to the angry principal. "He was so mad," she explained. "I never saw anyone so mad as him, but he wilted and finally said, 'Get back to class!' We wanted to know how it [the case] turned out."

The last class from Reynolds High School graduated in 1963 and had twenty-six students. The valedictorian of the class was Linda Mae Cook, and the salutatorian was Richard Dean Purdue. Reynolds students were then sent to North White schools in Monon.

The school was demolished in the 1980s to make room for a new elementary school that was built in 1987.

SCHOOLS

ROUND GROVE HIGH SCHOOL

Round Grove High School was built in 1922, but it wasn't a four-year high school until 1933, so its first graduating class was the class of 1935, which had six students. The schoolhouse was first constructed with no bathrooms. Instead, two outhouses served the students at first. Inside toilets were later added to the building. In the fall of 1963, Round Grove students went to Frontier schools in Brookston. Their teams were known as the Bulldogs.

WOLCOTT HIGH SCHOOL

Wolcott High School was built in 1901. The school added an assembly room upstairs and a gymnasium downstairs in 1921.

Then a large gymnasium addition was built in 1952. The gym was very tight, and bleachers were on only one side, according to Learee (Baker) Williamson, a 1956 graduate of the school. "That was one of the bigger classes," she said.

Learee said the classrooms could fit about twenty-five to thirty students, and the assembly room was the largest room in the school. She said they had dressing rooms in the basement. "We went down there for storms," she recalled.

Besides the regular classes, Learee took home economics in high school. "We didn't have a modern kitchen," she remembered.

Classes started the day after Labor Day, and Learee graduated in late May. This helped the parents, as many of the children in the school came from farms. Learee said the boys pulled the usual pranks, like bringing an outhouse to town and putting it out in front of the school.

Another one-story addition was built in 1962 to house the school's science room.

The last valedictorian of the school was Barbara Weisenberger, who graduated in 1963, and the salutatorian was Mary Glotzbach. The following school year, it became Tri-County High School, with some students coming from Benton and Jasper Counties. Tri-County used the high school building after the consolidation occurred.

Then on March 9, 1967, a devastating fire destroyed the original high school building, but the gym and latest addition were spared. Tri-County then used the old Round Grove High School and a couple of churches in town and in Remington. An elementary school now sits on the grounds of the old high school. The bell that was in the tower of the old high school is still on the grounds in memory of the old school.

6

BUSINESSES

Over the history of White County, hundreds of businesses have closed their doors. Businesses faded away for a variety of reasons. Some were lost in tragedies like fires and tornados. Many retail stores were hit hard when the Great Depression came in the 1930s. Only the ones that were essential remained, such as grocery stores, service stations, undertakers, hardware stores, lumber stores, coal sellers, ice suppliers and those others that are essential to the economy. The pandemic of 2020 also spelled the end for some businesses.

Few stores had more than one location in the county. One store that was in three communities was White's Five Cents to One Dollar Store. Alfred White opened the first store in Monticello in January 1947. The store was located on North Main Street between the Rexall Drug Store and Ace Hardware on the corner. The store went along fine in the 1950s. "It was ideal to have three dime stores in downtown Monticello," said Al. We had a tremendous business a couple of days before Christmas." The store had the second largest fabric sales in Indiana. "We had 188 different colors. My mom would give sewing lessons to people."

When the 1960s rolled around, Albert remodeled the store's façade to make it more attractive. He also opened a downstairs area and expanded into the rear of the building so he could carry more merchandise. He also helped get the city to build a parking lot behind the building to give the downtown area more parking. When a tornado hit the store in 1974, it was closed for three months, but it survived.

Businesses

White's Five Cents to One Dollar Store opened on North Main Street in Monticello in January 1947. Alfred White then opened stores in Brookston and Monon. *Al White photograph.*

Albert opened a store in Brookston in 1976. Another White store was opened in Monon, but the death of his uncle meant the end of its existence. Kmart opened in Monticello soon after the tornado and took business away from White's, so Al closed the Monticello store in 1979. He took over the store in Brookston until he sold it in 1982.

BROOKSTON

One of the first car dealers in the town was Dilts Motor Company, opened in 1926. It was owned by Jack Asher and was in the Nagle Building at Third and South Streets. It lasted for a decade before it was sold when Asher ran into health problems.

Bartlett Ford opened in 1955, when Kenny and Verna Belle Bartlett sold the New Idea Farm Equipment franchise and worked out a deal with Ford

Motors for a dealership. Other Bartletts worked there over the years, and in 2003, the company had twenty-eight full- and part-time employees. The last owners were Robert E. and Theresa A. Bartlett, but the business closed in 2015. Now, the site is a Casey's General Store, which was opened in 2017.

The Klein Brot Haus Bakery was founded by Kathy Richards in 1988. The German-like bakery lasted until 2014, and the bakery was sold to Two Guys Catering and Bakery. The building was constructed in 1903.

Recently, a fire destroyed an old building in Brookston. The Nagle Garage went up in flames on January 26, 2017. The garage was owned by Denny Clark of Lafayette Glass, according to the *Journal and Courier*. The building was used as storage by Clark and contained six classic cars, two boats, a couple of motorcycles and lots of collectables. *American Pickers* from the History Channel picked through the place about six months before the fire, said Marvin Ostheimer of Brookston. He had a 1975 Corvette show car in the garage. The antique store across the street, Relics Antiques, now has the façade of the building with "Nagle Garage" inscribed in stone for sale.

The old sign on the Nagle Garage in Brookston ended up in the street after the fire that destroyed it, so the previous owner of the Relics Antiques ended up with it to sell. *W.C. Madden photograph.*

BURNETTSVILLE

The town suffered a destructive fire on July 10, 1916, when a half block of buildings went up in flames. The fire was discovered at 11:45 p.m. and was gaining headway by then. It originated in a grocery store owned by L.N. Benjamin and spread to the State Bank building and Buchanan Hardware. A bucket brigade began putting out the flames before the Idaville and Monticello Fire Departments arrived to help. The bank building suffered the least because it was made of brick. Also affected by the fire were a dental office and a doctor's office. The State Bank later moved into a new building.

The town had lots of different businesses in its early days when travel was more difficult. When travel became easier, many of the businesses moved to larger communities, like Logansport and Monticello. Nowadays, there are only a couple of businesses left in the town, including J.H. Saylor Company, Betty's Quilting, Country Mark Service Station and Willie Mote Auto Parts.

CHALMERS

The town had many businesses until the middle of the 1900s. Then they all left for greener pastures and larger populations. Today, Meadow Lake Wind Farm is the largest employer in the town. The town is still home to Bella Motor Works, Country Mark Service Station and Northwestern Liquors.

IDAVILLE

The business portion of the unincorporated town of Idaville suffered a horrific fire in April 1902 that destroyed many businesses. The fire spread quickly because the buildings were all made of wood. One newspaper reported that the fire "swept away nearly all the dwellings." The fire began in the Bank of Idaville, possibly from a lamp, at about 4:00 a.m. From the bank, it swept south to a hotel owned by Frank Royer and Irelan's Grocery Store. Then it moved to a barn owned by W.A. Barnes, a store owned by Mrs. Henry Bennet and a Pennsylvania Railroad depot. A bucket brigade couldn't stop the fire from spreading to a jewelry store, barbershop, Bert Warden's Grocery Store and the *Idaville Observer*'s offices. After that, it spread to a butcher shop, Lew Reed's Hardware/Implement Store and a drugstore. Then it went on to destroy a blacksmith shop and three small buildings

owned by Joseph Henderson. In all, damages were estimated at $50,000, which is equivalent to about $1.7 million today. But the town recovered and progressed despite the fire.

Idaville had many businesses at the turn of the nineteenth century, but they started leaving soon after. The town has a few businesses today, such as Service Plus.

MONON

The town had about every kind of business until about fifty years ago. Then they started leaving. But the town still has a lot more than other towns in the county. It has several service stations, a Family Dollar, a liquor store, a new car dealership, two funeral homes and several other businesses.

MONTICELLO

In Monticello, a fire in 1884 destroyed two saloons and several merchants on the east side of the 200 block of North Main Street. Then on January 31, 1889, an early morning fire destroyed John Peet's Saloon, Gow's Cigar Store and Pettit's Restaurant. Response to the fire was slow because it occurred at 3:00 a.m. The flames quickly engulfed the three wood-frame buildings. It was thought the fire was started by a lamp that exploded or a cigar stub that was left on the floor. Some of the buildings' owners had no insurance, which is why they never recovered.

Goodman's Department Store was also called "The Big Store." Max Goodman started the business in 1878. The man from Russia ran the store into the 1900s. He trained his son Bernard to run the business before he passed away in 1918. Bernard later trained his son Julian to run the store. Bernard died in 1934. Julian decided to liquidate the store in 1956, after it had been in business for seventy-eight years. The store was last located at 103 North Main Street in a building that was constructed in 1890. The store was replaced on June 1, 1956, by Miller's Department store, which was owned by Jerry Alexander from Winamac. The store lasted into the 1990s and is now Alex's Apparel, owned by John and Jeff Alexander.

The Heath Tin Shop was a three-generational business. It all started when Henry L. Heath came to Monticello and opened a tin shop in the 1920s. Henry died at the age of sixty-nine in 1934, and the tin shop was turned

Businesses

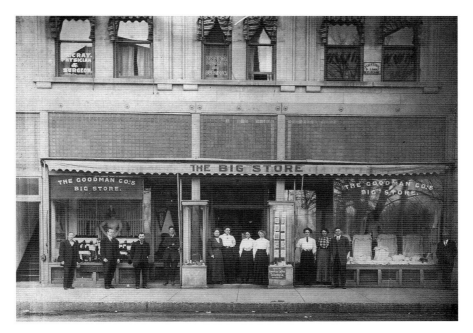

The Goodman Company Big Store was located where Alex's Apparel is now sitting at 103 North Main Street in Monticello. This photograph from the early 1900s shows some of the people who worked in the department store. *White County Historical Museum photograph.*

over to his son Raymond, who later moved the shop to Railroad Street. Raymond died in 1951, and the tin shop was operated by his son Robert. Robert sold the tin shop to Joe Cochran in 1958, when he decided to pursue a career as a conservation officer for the state. He was assigned as an officer for Jay County. What year the shop closed is unknown.

The Monticello Floral Company started in 1909. One of the founders was Cloyd Switzer. He died in 1944 at the age of sixty-four, but his family ran the business until April 21, 2012.

Another store that lasted a long time in Monticello was Memco Carpet. The business opened in the 1950s and was located on Third Street. It was owned by Raymond and Dorothy Memmer. They were married on December 16, 1944, in Tacoma, Washington. Memco Carpet sold carpet, of course, as well as vinyl tile, which was popular in those days. The store also sold custom draperies. The business later moved to 620 North Main Street in the 1970s. The building is now owned by the Quilted Bee LLC. Raymond died on March 3, 1987, and Dorothy then decided to close the business. Dorothy passed away on July 1, 2013, at the age of ninety-three.

Left: Memco Carpet was originally located on Third Street in Monticello. The sign and buildings remain, but the property belongs to the Northern Indiana Public Service Company. *W.C. Madden photograph*.

Below: The tornado severely damaged the White County Courthouse, which was built in 1884. White County decided to demolish it and build a new structure. *White County Historical Museum photograph*.

On April 3, 1974, a powerful tornado ripped through the heart of Monticello, destroying many buildings and damaging others. Many businesses had insurance and were able to recover. The same can't be said for some of the other buildings.

The largest building destroyed was the old White County Courthouse, which was originally built in 1884. Making repairs would have cost almost as much as building a new courthouse. The White County government chose the latter. Some people criticized the design of the new courthouse and said it looked more like a parking garage.

One of the stores that was destroyed by the tornado was the Ben Franklin Dime Store on South Main Street. George Coy and his wife purchased the store in 1957. When the tornado hit, Ione Gallinger of Idaville was in the store and died in the building's collapse. The building was so damaged that the Coys decided not to continue the business. Many other stores and businesses were also lost because of the powerful storm, including the Monticello Telephone Company building on Court Street.

The COVID-19 pandemic spelled the end for many people in White County. It has also led to some businesses closing their doors for the last

Karen and James Schmitz stand in front of their store, KJ's Crafts and Everything. The store decided to close its doors in 2022. *W.C. Madden photograph.*

time. But that's not the reason KJ's Crafts and Everything closed its doors. The owners are now in their seventies and want to retire.

Because KJ's Crafts and Everything was closing, Karen and James Schmitz dropped their prices by as much as 50 percent. If you thought something was too expensive, you could bargain, and they would probably drop the price more to make you happy. Karen might have even thrown in a free item because you bought several others. Her husband, James, or "Jim," didn't say much. He's the silent type, but she's the opposite of him and does most of the talking to customers. She recently retired from her day job as a janitor at Twin Lakes High School due to her health. They are both in their seventies and are starting to feel their age.

The KJ's Crafts and Everything building was originally constructed in 1943. It was first home to the Clark and Moore Packing Company, which dealt in meats. In 1988, some renovations were done to the building. Then in the mid-1990s, its name was changed to Monticello Meats, owned by David and Tisha Clark. Ire Moore retired and moved to Florida, according to Judy Baker, the director of the White County Historical Society.

"One of them [Clark or Moore] stopped in after I opened," said Karen. "He was in his eighties." The Schmitzes purchased the building at the beginning of the twenty-first century and opened KJ's in 2002. When it first opened, the store was open longer and for more days a week than it is now. Now, the store is open only on the weekends. Karen and Jim arrive around 10:30 a.m. on Saturday mornings and stay open until 5:00 p.m. or when the customers are done. On Sunday, the store is open from 1:00 p.m. to 5:00 p.m., because Karen and Jim attend Faith Covenant Fellowship in Monticello. Karen believes in loving everyone, but if she doesn't like someone, her preacher said, "Wipe your shoes and move on."

Another reason why some businesses close is the death of an owner. Such was the case with Garden Station on West Broadway, owned by Mike and Betsy Dill.

The place used to be a gas station and has a long history, as it was first built in 1936, according to the White County Assessor. The first owner of the building was the Mummert Brothers company, which was located at 228 West Broadway behind the First Presbyterian Church before moving.

Tiger Creek LLC took ownership of the abandoned gas station in 1995, and the Dills opened the Garden Station. They left behind the old gas pump as a reminder of what the building was originally.

Mike grew up in an area called Dillville between Monticello and Delphi. He moved to Maryland to work in grounds maintenance and development

The Garden Station on West Broadway in Monticello closed its doors in July 2022. *W.C. Madden photograph.*

at the University of Maryland, which is where he met Betsy. They were married in 1992 in Wheaton, Maryland, and ran a local landscaping business, Brookside Gardens, from 1993 to 1995. Then they purchased the old gas station in Monticello.

The Dills owned the building for nearly a quarter of a century before Mike passed away on November 9, 2020, from complications related to a heart attack. Everyone remembers him as the man with the large, gray, bushy mustache. His wife, Betsy, continued to run the station for another year before deciding to sell out and move to Maryland in July 2022. She found it too hard to run the business without her husband.

Betsy made her final sales of 75 percent off starting in mid-May 2022, and the place was jammed with shoppers wanting to pick up her goods at that price. She didn't purchase any flowers for the season, so she didn't have a problem with disposing of the plants she had purchased for the year. She had plenty of gifts, plaques, memorial garden mementos, art wall hangings, et cetera.

Another business that closed after the death of an owner was Elaine's Pack and Ship, which existed at 623 Turpie Street from 2003 to 2012. Owned by Elaine Berner, the place provided balloons, gifts, antiques and a way to ship packages via UPS or FedEx. Berner decided to retire after her husband developed cancer so she could take care of him. She sold the business to Ship and Dip, which moved the business. Before Elaine's Pack and Ship, Berner said a printing company was in the building, as was a Pizza King at one time. The building was constructed in 1939 and was remodeled in 1988. It was owned by George and Debra Huffer McDaniel until they sold it in 2001

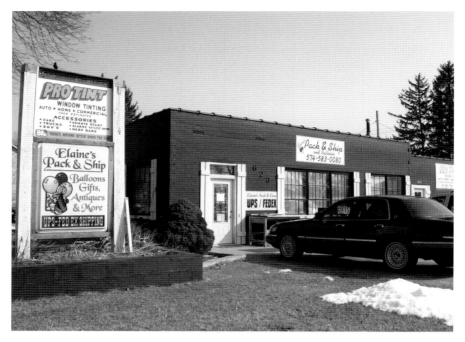

Elaine's Pack and Ship was owned by Elaine Berner and located on Turpie Street in Monticello. *Elaine Berner photograph.*

to Francis R. Edmondson for $50,000. He sold it to Estudillo Raymond for $90,000 in 2020. Raymond erected a fence around the building to house his construction equipment. He calls his business Ray's Construction.

Aardvark Electronics came to Monticello in the early 1990s and was located on Rickey Road. The owners, Doug and Leslie Motel, decided to build their own store on Sixth Street in 2001. They offered the latest electronics to their customers. "It's your electronics toy store," said Leslie. The store lasted until 2009, when the couple decided to retire.

Kmart had a store in Monticello for quite some time until a Walmart opened on the other side of the city in the twenty-first century. That spelled the end for Kmart.

REYNOLDS

Reynolds was founded in 1854 by Benjamin Reynolds and became incorporated in 1875. The town thrived in the 1800s, as it was home to

Honey Creek Township's first steam sawmill. And in 1855, a schoolhouse was built. Described as rivaling Monticello in population, opportunity and businesses, Reynolds was bustling in the second half of the nineteenth century. The town that would be the first in Indiana to offer its citizens free moving pictures was almost wiped from existence because of early construction methods in towns that grew quickly in the Midwest. Reynolds faced the near destruction on August 27, 1907, when lightning struck a telephone pole. The entire length of Second Street and a block of the business district in Reynolds was reduced to rubble in the resulting fire. The businesses destroyed included a blacksmith shop, an implement store, a post office, a barbershop, a saloon, a shoe store, a restaurant and a grocery. Two homes were also destroyed. The damage came to total $25,000 ($806,000 today), and the town was rebuilt using bricks instead of wood.

The Rambling Rose Tavern opened in the town after Prohibition ended in 1933. It later became the Red Arrow, Rose Tavern and Country Crossroad. Now, it's called Willoughby's Country Crossroads Bar and Grill and is owned by Scott and Jackie Willoughby.

One of the most successful businesses to start in Reynolds was Hardebeck Trucking. Robert and Carol Hardebeck started the company in the 1970s northwest of the town. The couple had purchased a 320-acre farm there in 1970. They purchased their first semitruck in 1975, and the company was incorporated. Initially, the trucks were used for farming operations. The company branched out in the 1980s and moved agricultural products. The couple gave up on farming in 1988 to concentrate on the trucking operation. They opened a Monticello location with offices and a maintenance shop on Sixth Street in 1991. In 2000, they built a large warehouse to expand their services. The couple retired in 2002 and left the operation to their children. In 2013, the business was sold to 384 Monticello Terminal LLC for $2.6 million.

Ezra Car Sales started selling used cars at the main intersection in town in 1989. Ron Ezra passed away in 2010 and left the business to his daughter Debbie. She ran the business for about a decade before it went out of business. Red Rose Liquor opened a store at the location in 2023. The Shortstop Liquor Store was located on the corner across the street from Ezra Car Sales, but it closed in 2022. The business was started there in 2010.

WOLCOTT

A fire occurred on the night of January 29, 1902, destroying much of the business section of the town. The tragedy made national news. The business section of the town was wiped out, with more than $129,000 worth of goods and storefronts lost. Some papers even compared the incident to the Great Chicago Fire of 1871.

The actual cause of the fire and where it started was never confirmed. The Odd Fellows held a meeting the night before, and it was speculated that someone likely left a lantern glowing in the building. More than twenty business firms, professional men and secret societies were homeless when the sun came up Wednesday morning.

All the papers agreed on the path of the fire and the area impacted, but they disagreed on the amount lost, with some reporting the loss at $50,000. The fire started in the Spencer Bros. Drugstore on West Market Street and then crossed and caught the Carson & Co. Dry Goods and Clothing Stock on fire. This led to the Panhandle Railroad track, which was warped as it fed the inferno. Market Street, the Panhandle Railroad track, Second Street and Range Street formed one large mass of fire. The building that received the least damage was the Masonic building located at the corner of Market and Range Streets, at the time the home of Hart Drug Store and the Bank of Wolcott. The building benefited from more modern fireproof construction, proving it to be successful. On the west side of Market Street, the two-story buildings of Spencer Bros. Drug Store and Hinchman's Hardware and the one-story buildings of Snickerberger's Barber Shop and the post office were left in ashes. During the late nineteenth century and early twentieth century, Wolcott experienced many disastrous fires, but the 1902 fire remains the worst in the town's history.

The businesses reported the following losses: James Blake Furniture Store, $5,500; John C. Pitts Building, $2,350; Spencer Bros. Drugstore, $3,000; Lewis Hinchman Hardware, $2,500; W.F. Bruker Building, $3,000; C.W. Baker Building, $2,000; I.O.O.F. and D. of R., Logger Fixtures, $100; John Snickenberger Barber Shop, $250; post office fixtures and building, $500; Dr. Cronk office, $2,000; Carson and Co. Dry Goods and Clothing, $14,000; Johnson Building, $2,200; Jake Clous Tailor, $50; D.K. Jackson Meat Market Building, $650; Mrs. Sadie Davis Building, $650; Thos. Jackson Building, $650; Smith Bros. Grocery Store, $3,200; N. High Building, $2,500; A. Leopold and Son, Merchandise, $20,000; N. High Opera House Block, $3,500; Martin Snickenberger Harness Shop, $700; Geo. Fergerson Hotel,

building and fixtures, $8,000; Burke Bros. Saloon, stock and fixtures, $2,500; Amos Johnson Building, $1,500; E. Preble, pool room fixtures, $50; Alva Smith, restaurant stock and building, $3,400; Blake Lumber Co., buildings and stock, $50,000; F.E. Hart Drug Store, $500; Masonic building, $500; and J.G. Kerlin Philip Bros. and A. Ellis, $350.

A vacant building now sits on the curve of that busy stretch of U.S. 24 that leads out of town. The location was ideal for a gas station. In the 1930s, the building was home to Churchill's Texaco Station, managed by Jack Churchill. The owner ran advertisements in the local newspapers, saying, "Don't drive on worn tires. Come on in and let me make you a price on a set of tires today." The advertisement also enticed readers by giving details about the lunch counter inside that served homemade pies, coffee, cakes, sandwiches, refreshments, cigars, cigarettes and candy. R.A. Shobe took over the station in June 1939. Car Nelson later owned it. Then it became Furrer's Cities Station and still provided Texaco gasoline twenty-four hours a day. The building last became Sterrett Liquors, and the lettering can still be seen fading away on the glass door, now only a memory of the past.

Located on the south edge of Wolcott is a home that was once the operations base of a business. Roth Service Station at 624 South Range Street was operated by Roy Milton Grugel and his wife, Bertha Lane. Gruel was born in 1905 and provided a service station for the Wolcott community throughout his life. When he passed away in 1987, he was remembered for his years of service to Wolcott. The house remains today as a reminder of his commitment to his community.

7

RESTAURANTS

The restaurant business is risky sometimes, and many restaurants fail due to several factors. White County has seen its share of failed restaurants over the years. However, there were some that lasted for decades, showing that they were favorites.

Although White County is not very large, with a population of about twenty-five thousand, it has seen its share of national chain restaurants come and go. The phenomenon of chain restaurants began in 1919 with A&W, but it really picked up steam in the 1950s with fast-food restaurants, which started showing up in White County soon after. A&W once had a root beer stand in Monticello. It was called Frank's Drive-In, and it was owned by Frank Bykoski and, later, Lloyd Capper.

The first drive-in eatery was the Dog n Suds on Northwest Shafer Drive in Monticello, near the north entrance to Indiana Beach, in 1959. The chain was started in 1953 in Champaign, Illinois. At its peak in 1968, the chain had about 650 restaurants. When the Monticello location closed is unknown. The location was later taken over by John's Bakery, which later moved to a location on Sixth Street before closing in 2020.

Burger Chef built a restaurant on North Main Street in Monticello in 1969. The company was founded in 1954 and opened its first restaurant in Indianapolis in 1957. The chain went defunct after it was sold to Hardee's in 1996. The Burger Chef in Monticello was sold in 1994 to Arby's, which remains in that location today.

RESTAURANTS

Top: Hardees used to be in this building that is now occupied by Arby's on North Main Street in Monticello. *W.C. Madden photograph.*

Bottom: The Delta Cone was housed in the old Dairy Queen building at the beginning of the twenty-first century. *W.C. Madden photograph.*

A Kentucky Fried Chicken restaurant came to Monticello in the 1970s. By then, the chain had grown to have more than three thousand outlets in forty-eight countries. The KFC in Monticello lasted for a while until the White County Health Department closed it for its unsanitary conditions. The location is now occupied by Verizon Wireless at the corner of Fisher and North Main Streets. KFC was founded by Colonel Harland Sanders, and the first KFC was opened in 1952. In 1964, Sanders sold his chain to a group of investors.

In 1963, Dairy Queen first came to Monticello on North Sixth Street. The following year, it was ripped apart by a storm. It was reopened on May 28. The first DQ opened in Joliet, Illinois, in 1940. When the DQ closed here is unknown, but in the twenty-first century, the Delta Cone opened there, owned by Mike Kalogeras. He sold ice cream, fried chicken and sandwiches there. The building is now a Taco Express.

91

BROOKSTON

The first restaurants in Brookston were Millers Brothers Restaurant and McClean Café in the 1920s. The Millers brothers changed the restaurant's name to Millers Brothers Café, which lasted into the late 1940s.

In the 1930s, the Getreu Restaurant and Stanley Café opened in the town. Burton's Restaurant opened in 1961.

In the 1940s, the Palmers House was run by Charley and Gloria Palmer.

The DeBoy's Café and Miller's Café opened in the 1950s.

The 1960s brought Capper's Café and Price's Corner Café, which later became Brook's Corner Café.

The town has had two eating establishments for a long time and still does, J&J Road House, which has been owned by James and Joseph Richardson since 2004, and Pizza King, which was opened in 2015 by Robert and Tera Johnson.

BURNETTSVILLE

Miller Restaurant was the first restaurant to open in Burnettsville in the late 1920s. In the 1930s, Perkin's Café opened. The Canary Drive-In opened in 1951. Dean's Midway Drive-In opened in 1967.

At the beginning of the twenty-first century, Cindy and Kenneth Brummett opened the B-Ville Diner, which served breakfast, lunch and dinner. The

The B-Ville Diner closed in 2022. The building was vacant in 2023. *W.C. Madden photograph.*

interior had the look of an old-time diner with a checkerboard floor, red plastic dining chairs, an old four-seat counter and Coca-Cola memorabilia on the walls. Kenneth passed away in 2005. Her customers gave the diner a facelift in 2019 on a sunny fall day. However, the COVID-19 pandemic hit the following year, so it had to close for some time. It never recovered, and the Brummets sold the diner to Snap8 LLC for $45,000 in 2022. Now, it is vacant. The building was first built in 1916.

CHALMERS

The first restaurant in Chalmers was the Little Guy Café, which opened in 1919. It stuck around for three decades. By the 1940s, the town had two other restaurants: C.C. Palmer and Levi Hurn. Chalmers Café opened in 1961 and was owned by Roy Swaim.

One building that was constructed in 1900 on Main Street in Chalmers has been the site of several restaurants. BCs of Chalmers was located there, as was Michaels of Chalmers, which was a steakhouse. Michaels closed in 2022 and may have been a victim of the COVID-19 pandemic that swept across the county in 2020 and 2021. The building became the Chalmer House in May 2023. The building is owned by Michael Hicks, according to White County property records.

IDAVILLE

The Noah Johnson Restaurant opened in 1936. Near Idaville on Indiana 24 was the Three Way Inn, which opened in the 1930s.

MONON

The Monon Restaurant was opened in the early 1900s. The Garwood Café came about in the 1920s. The Lerch Lunch Room was opened in 1938.

The place to go in the 1960s was the Sugar Bowl, a hangout where teens could eat and play music on the jukebox. The Sugar Bowl was owned by Carol and Marie Hughes.

Myron Stanley and his mother opened Stanley's Café, which is where the Trailways Bus made its scheduled stop. Riders would disembark

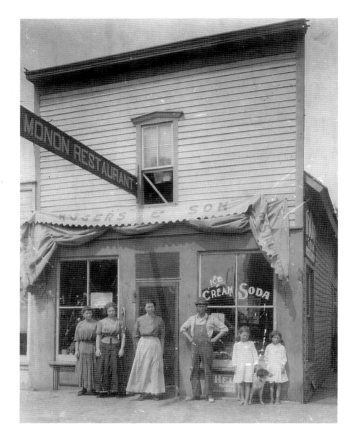

The Monon Restaurant was in business in the early 1900s. It was owned by Roger and Sons. *White County Historical Museum photograph.*

from the bus and head for Stanley's for a bite to eat before they hit the road again.

The Monon House was also popular with train riders. Located across from where the historic Monon Depot now stands, the Monon House was the place to go for residents.

And there was the South Side Café, owned by Milton Tyner. Today, there are several restaurants in the town, including the Monon Pub and Grill, Mi Pueblito Market and Restaurant and the Whistle Stop.

MONTICELLO

In 1873, John Burns opened a restaurant at 109 North Main Street. Burns advertised that his restaurant was the oldest in the county. Burns' Restaurant served a variety of foods, including oysters. The restaurant

RESTAURANTS

could seat up to one hundred patrons and provided a full line of cigars and confectionery. Other owners who kept the restaurant going into the 1920s were Ben Ross, Fred Perry and John Burns. The location is now occupied by Necessities, a trendy fashion retailer, providing quality items. The owner is Ingrid Landis.

One of the first restaurants in Monticello was owned by William Roth and was located at 234 North Main Street in 1914. The Strand Restaurant opened in 1917 and sat next to the Strand Theater, which also opened in 1917. John Reeder was the owner, and he sold it to Frank Benjamin in April 1920. Then Mr. Hughes purchased it from Benjamin in August 1922. It soon changed hands again to C.M. Bushey and wife in August 1926. The Busheys sold it to Mrs. Louise Dake of Shelbyville in March 1928.

The Almo Café came about at the same time the Strand Restaurant opened. Then Van's Café opened at 120 North Main Street. The café served lunch and dinner and specialized in steaks. Van's folded in the early 1950s.

In the 1930s, Braugh's Coffee Shop opened at 234 North Main Street. It was owned and operated by Lowell Braugh, who died in 1941. The Monticello Police Department is now located at the same location but in a different building. Broadway Café opened at 111 West Broadway, Chilly's Café opened at 134 North Main Street and Webster's Café opened at 101 South Main Street. The Broadway Café lasted into the 1950s. Shafer's Café was located at 131 South Main Street until 1952, when Bertha May Gilsinger decided to close it after her husband passed away.

After World War II ended, several new restaurants began to open in the city. The Lakes Café opened at 101 South Main Street, the Log Cabin and Randall's Restaurant opened on North Main Street and the White Kitchen opened at 209 North Main Street. The Log Cabin had drive-in curbside service.

In 1950, a new restaurant opened on Lake Shafer, near Lowe's Bridge. Riverview Park opened with a restaurant in an old log cabin and trailer spaces. Owned by Newby and Valeria Apple, it became the first trailer park on the lake. The restaurant featured some of the best barbecue in the area. It would hickory smoke some two hundred to three hundred pounds of ribs and chickens a week. The meat was cooked outside in a smoker. People either ate in at the restaurant's eight tables or took out. However, Newby passed away in 1958, and Valeria had a hard time running the restaurant, so it was closed soon after that.

The 1950s brought about more new restaurants. Van's Café was replaced by Court Café, but it didn't last long. Dean's Restaurant opened at the corner

95

This old log cabin used to be the Riverview Park Restaurant in the 1950s. *W.C. Madden photograph.*

of South Main and Washington Streets. The Wagon Wheel opened at 204 North Main Street and was owned by A.C. Risko. It served chicken, seafood and steaks. Murdock's Restaurant opened at 209 North Main Street in the late 1950s. The Italian Gardens also opened near the Monticello Drive-In.

Also in the 1950s, the Holiday Inn existed as a restaurant—not a hotel of the same name. The hotel chain of the same name was also created in the 1950s and was officially called Holiday Inn of America, so the restaurant wasn't violating copyright. The restaurant also went by the name Laverne's Holiday Inn in the phone book. Laverne served up chicken, seafood and steaks. The restaurant also provided catering and hosted events, such as weddings.

The Frosty Mug opened in 1954 and immediately became a hit with the teens at Roosevelt High School, just across the street, with its steamburgers and root beer. Bill and Ruth Kretchmar created its motto: "Good food fast, not fast food." They soon installed forty-eight speakers for people to order food from their vehicles instead of making them line up at the window. "When we got the speakers, business really took off," said Ruth.

The business did well until McDonald's came to town in 1978. So, the Kretchmars decided to build a new restaurant and called it the Tree House, offering some of the items off the Frosty Mug menu. In 1990, they decided to retire and sold out to Dick Frey. The restaurant is now called Harvest Time.

Pizza Hut was the first chain pizza restaurant to open in the area in 1958. The first pizza place in White County was the Wagon Wheel Pizza, which opened in 1960. Also in the 1960s, the Tastee Freez opened at

Restaurants

The Frosty Mug was built by Bill and Ruth Kretchmar and was an immediate hit with teens. *Ruth Kretchmar photograph.*

the Point, and Young's Cafeteria opened at 111 West Broadway, serving breakfast, lunch and dinner seven days a week.

The Spot Drive-In opened in 1959 on Rickey Road across from the Monticello Drive-In Theater. It was owned by Bill and Inez Criswell. In 1972, the restaurant changed its name to Spot Restaurant, as it provided seating inside for seventy people but still had twenty service phones outside. It served a variety of items, from sandwiches to steaks. The location is now owned by USA Restaurant and has only inside seating.

The Busy Bee Drive-In opened in June 1963 across the street from the Spot Drive-In. It was a drive-thru with a drive-up window. The restaurant sold burgers for fifteen cents like McDonald's did. It had a spacious dining room inside. It was owned by the Youngs, but it lasted only a couple of years. Now, it is the site of the USA Restaurant.

Ashton's Restaurant opened in 1970 at 209 North Main Street, as did the Frostop at 902 North Main Street. Arf's Hot Dogs opened at the corner of Fisher and Main Streets in 1971. Near Indiana Beach, La Rays Restaurant opened the same year at the Lake Terrace Motel.

The Shafer House opened in the 1970s, overlooking Honey Creek Bay by Indiana Beach. It specialized in Chinese food. Later, it became the Crab Pot, famous for its clam chowder served in tin pots. Another change of hands resulted in the restaurant becoming Lauer's by the Lake. Then on May 22, 1991, Benno Lagemann and his wife, Mercedes, purchased the restaurant and renamed it Benno's by the Bay. The couple owned it for eleven years.

"Every year, we had a traditional Oktoberfest celebration at the restaurant," said Mercedes. Then they decided to lease it to two ladies, who renamed it Mulligans, but that restaurant failed, and the building remained empty for many years. Now, firewood is sold out of it.

In the mid-1970s, the Forvm Restaurant opened 329 North Main Street. Four local businessmen—Win Gilbert, David Dellinger, Ralph Jones and Earl Hornback—financed the original building, which is why some think the name came from them; however, the word *forvm* means "meeting place" in Latin. The building was constructed in 1972 and was originally a package liquor store with a restaurant. In 1986, Jerry and Jolene Miller took over, and there were only three employees. "When we sold it, there were twenty-one full-time employees," Jerry said. "We made everything by hand. We didn't purchase frozen food, warm it up and serve it. On weekends, guests would stand in line waiting to be served." They ran the restaurant until 1992. Then the building became a Blockbuster until that company went bust in 2014. Now, the building is rented to American Rental.

Coffee shops started showing up in Monticello in the new century, but some have already been lost. One was the Perfect Blend, which Lana Caster opened at the corner of Harrison and Main Streets. It featured gourmet coffee, espresso, tea, smoothies, bakery items and lunch. The coffee shop lasted a couple of years and is now a beauty parlor.

At the end of the twentieth century, Dan Sublette opened Sublette's Ribs on Sixth Street. The restaurant featured barbecue, chops, steaks, seafood, salads and sandwiches. "I always loved to cook," said Sublette. The restaurant was going along fine until a fire burned it down. Sublette rebuilt

The Perfect Blend was located on the corner of South Main and Harrison Streets. It's now a beauty shop. *W.C. Madden photograph.*

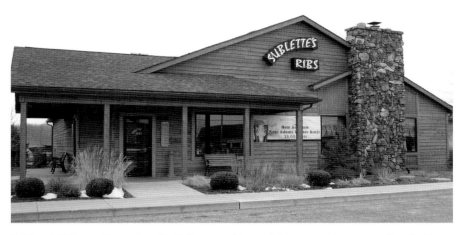

Sublette's Ribs was located on Sixth Street and burned down once, but owner Dan Sublette rebuilt the restaurant. He then sold it to one of his former workers, who renamed it Oak and Barrel. *W.C. Madden photograph.*

it and ran it for a few more years before selling out. The Oak and Barrel is now housed in the building.

Some restaurants don't last very long, and in recent years, there have been several in Monticello that fell to the wayside not long after they opened. The Kopper Kettle Bakery and Café had high hopes when it opened on North Main Street in 2019. However, owners Jammie and Jamie Propes didn't have the experience and lasted less than a year.

The Lyme in Monticello also fits into this category. It was opened by some recent graduates of Twin Lakes High School. Elvin Gutierrez and Nick Mendel opened the eatery in May 2021. It immediately caught the interest of the community, and business was good. It featured salads, bowls, sandwiches, pasta, tacos and breakfast. It was open from 7:00 a.m. to 4:00 p.m., so it catered to the breakfast and lunch eaters. The restaurant closed for the fall and winter and didn't reopen until the spring. It closed permanently in August 2022. The eatery was located on Sixth Street where the old John's Bakery existed for many years. Gutierrez and Mendel completely rehabilitated the space and made it look quite different than the old bakery, which had a dining room. The restaurant equipment was later advertised for sale. The location remained empty until May 2023, when Mt. Fuji Sushi and Hibachi opened there. It was the first Japanese restaurant in the county.

B's Greek Grill opened in the summer of 2022 on North Main Street. It was open for about year before it was closed up and the building was put up

for sale. It served its meals on disposable plastic plates instead of good china. The building is owned by Mei Jenny and Xian Bin, according to White County property records.

The year 2023 saw the demise of Monical's Pizza in Monticello. The restaurant on South Main Street had been there for a long time, but apparently, the chain was hit hard by the COVID-19 pandemic and closed several stores at the beginning of the year, including the locations in Monticello and Delphi. It still has many other restaurants across Indiana and Illinois. The restaurant has franchise opportunities available in six states.

NORWAY

Several restaurants were opened in the community north of Monticello by the Norway Dam. Fisherman's Paradise was built there in 1928 by Harry "Fuzz" Arrick. For many years, Horace Templeton managed the restaurant. The restaurant transferred ownership to William Sullivan, and then it burned down in November 1950. The Twin Lakes Fish and Game now occupies the corner where the restaurant used to be located.

The Fisher's Inn was built in Norway in the 1920s. Then Bill Wert built a fish house there in the 1930s. Horace Templeton purchased the restaurant in 1950 and changed its name to Angler's Restaurant. Little Hollywood, which was owned by Ben and Gary Sorrell, was located along the Tippecanoe River

Fisherman's Paradise was built in Norway in 1928. *White County Historical Museum photograph.*

RESTAURANTS

in a building that was constructed in 1900. Then Gary and Paula Cosgray purchased the building in 1989 and turned it into Riverside Restaurant. The couple sold it to Jeff Van Weedlen in 2011.

REYNOLDS

In Reynolds, Mike Ruppert opened the Green Gables Restaurant in 1930, but he closed it for two years during World War II. He sold it to Clem Foster in 1944. Roy Heady took it over in 1952. The restaurant was closed in 1979, and the building became a service station, which it remains today.

Solly's Red Arrow began business in the late 1950s. The restaurant was owned by Burdell Salomon, and it became known for its great steaks. It would last into the twenty-first century before folding in 2003. On December

Top: Green Gables Restaurant opened in 1930 and lasted until 1979. The building is now a service station. *Fotoshop photograph.*

Bottom: Beaks & Fins closed in 2018, but the building was first used by Solly's Red Arrow in the 1950s. *W.C. Madden photograph.*

5, 2016, Randy and Susan Elizade opened Beaks & Fins at the same location and tried serving up chicken and fish, but the restaurant failed after a year and half. The building remains for sale.

The Frosty Freeze opened in Reynolds in the 1960s. Owned by Larry and Phyllis Hoover, the walk-in restaurant remained into the twenty-first century, but it was closed to the public a few years ago, and a trailer is being used to house the restaurant instead.

In 1970, Gardiner's Fine Foods opened for breakfast, lunch and dinner, serving chops, steaks, seafood and homemade pies.

WOLCOTT

The Hoover Restaurant and J.H. Café operated for a while in the 1930s. The Midway Café opened in the late 1940s. Gram's Café opened in the late 1950s. The Chipendale Restaurant opened in 1960, and the Little Grill the following year. The Branding Iron Drive-In also opened in the 1960s on North Fourth Street. It also lasted until the 1970s. The Curve Inn opened in 1967.

The Country Inn lasted into the twenty-first century before closing. John and Darlene Flynn owned the restaurant, which featured huge breaded tenderloins, catfish and prime rib. The place is now called Roots Eatery and Pub.

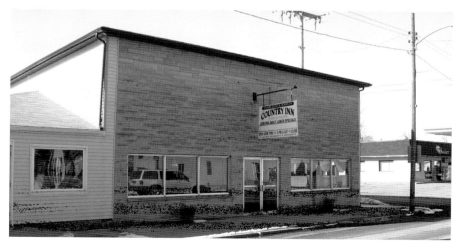

The Country Inn in Wolcott was owned by John and Darlene Flynn. It's now Roots Eatery and Pub. *W.C. Madden photograph.*

8
ENTERTAINMENT

BANDS AND ORCHESTRAS

The county once had several bands and orchestras. The first band in Monticello was organized in 1852. Later in the nineteenth century, the band was led by Dr. Robert Spencer, who also played the clarinet.

The county had the Monticello Orchestra, which was started in 1909. The last time it performed is unknown.

The Monticello Community Band was restarted in 2018 and lasted until the COVID-19 pandemic of 2020. In 2023, a group calling themselves the Community Choir played and was led by Brad Seward, the band director at Monticello Christian Church.

Bandstands were also once used by these bands in Monticello and Monon in the late 1800s and early 1900s. The old bandstand in Monticello was later moved to the City Park, but it has since been removed. Monticello now has a gazebo by the White County Courthouse that is used by bands.

IDEAL BEACH

In September 1925, Shafer Lake was drained to help fill up Freeman Lake after the completion of the Oakdale Dam. Earl Spackman took the occasion to have gravel brought in by mule teams to lay down a base for his beach on top of the mud that was once a cornfield. The gravel was spread

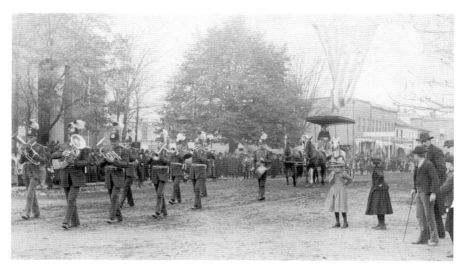

The Monticello Band marches down Main Street in Monticello during a parade in 1893. *White County Historical Museum photograph.*

manually, using shovels and two-by-four pieces of wood. Then he brought in tons of sand. When the lake was filled back up, he had his man-made beach. He then constructed a bathhouse, pier, picnic pavilion and a small refreshment stand to be prepared for the next summer. He spent about $5,000 (about $64,000 today).

On June 16, 1926, Spackman opened his Ideal Beach for the season. Besides providing the beach for swimming, he also rented out rowboats. He sold goodies at his concession stand. He charged adults a quarter, children under twelve a dime and children under six nothing. He advertised in local newspapers. His teenage son Tom helped him run the concession stand. Spackman also had four one-room cottages for rent. The cottages featured cement floors, oil stoves and two beds, a table and chairs in each.

At the end of the summer, Spackman reported that he didn't show the profit anticipated and blamed the bad weather. However, he did have some good participation from groups. The largest group was from Union Station and the Belt Railroad in Indianapolis. More than three hundred of the railroad's employees took the Monon train up to Monticello on a Sunday in late August. Then Spackman provided bus transportation from the train station in Monticello to his beach. The group also had a picnic, a beauty contest and a baseball game. Another group that visited the beach comprised more than one hundred employees from Interstate Public Service Company.

Entertainment

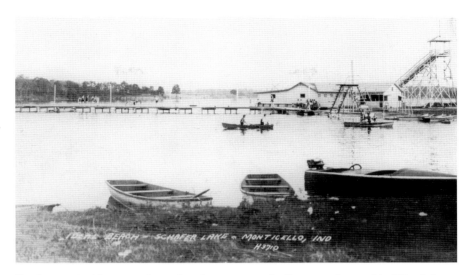

Rowboats, a bathhouse, a pier and a toboggan were the first attractions at Ideal Beach in the 1920s. *Vintage postcard.*

In the fall, Spackman sold Ideal Beach to George Spurlock, who built a hotel and a dozen cottages in the off season. The hotel had seven rooms for employees and twenty rooms for guests. It also had a large dining room.

In 1927, Ideal Beach continued to grow, with Spurlock adding a toboggan ride, a water wheel and a diving platform on the pier for swimmers. The thirty-foot-long toboggan allowed people to make a big splash in Shafer Lake. Spurlock opened the beach on Friday, May 27. It was the day before Decoration Day (now called Memorial Day). Apparently, things didn't work out for Spurlock, as he sold the resort back to Spackman at the end of the season.

For Ideal Beach's third season, Spackman added another attraction—a passenger boat. The boat's trip took more than an hour and ran every hour and half. The fare was a quarter. Spackman also began selling fireworks at his refreshment stand.

In November 1929, Ideal Beach announced it would be building a large dance pavilion. The hall would be eighty by one hundred feet. The facility would be heated and used all year. During July and August, dances would be held nightly. The opening would take place on Decoration Day.

The best-laid plans of Spackman to have a dance hall called the Indiana Beach Casino went up in flames the morning it was supposed to open, Memorial Day 1930. Just hours after construction was complete,

a fire broke out at 2:30 a.m. on May 30. Frantic calls were made to the Monticello Fire Department, but it failed to respond because the property was outside its jurisdiction. Had it responded, it probably couldn't have done anything but watch the flames consume the building, as the structure was made of wood and highly combustible. The cause of the blaze was never uncovered. The blaze also claimed the refreshment pavilion and decimated the beach's fleet of eighteen rowboats. The bathhouse and hotel were spared. A couple of days after the blaze, an undaunted Spackman announced he would be rebuilding the hall and opening by July 4. He also delayed opening the beach until June 15. Spackman's employees worked feverishly to get a new dance hall completed, and it was ready by June 18. On Fourth of July weekend, from July 4 to July 6, Ideal Beach shot off a fireworks extravaganza called "The Battle of the Seas." It also held boat races. Thousands flocked to the beach for fun.

The Spackman family decided to build a permanent home on their property at Ideal Beach in 1931. By September, Spackman's company had gone into receivership, with heavy debts amounting to more than $5,000 ($81,000 today).

Beginning in 1931, Spackman brought in a lot of local and regional bands, including the Monticello Boys' Band, the St. Louis Blue Blowers, Karl Lane

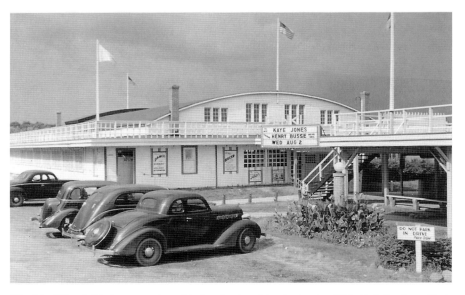

The Ideal Beach Casino was where big bands played beginning in 1930. *Ruth Spackman Davis photograph, vintage postcard.*

ENTERTAINMENT

and His Campus Boys from the University of Illinois, et cetera. Many of the orchestras found it convenient to stop at Ideal Beach while traveling from Indianapolis to Chicago or vice versa. Spackman kept prices as low as possible, because many people were out of work due to the Great Depression.

On July 4, 1931, Ideal Beach was packed, and traffic jams resulted in Monticello. Back in those days, people had to drive down Main Street (a two-way street) to get to Ideal Beach from the south. Monticello police chief Bert Rose reported more than two thousand cars traveled through the city between 10:00 p.m. and midnight. A steady stream of vehicles left Ideal Beach at 12:45 a.m. Ideal Beach reported its largest crowd ever, with more than two thousand people using the bathhouse.

In the off-season, Spackman tore down the old bathhouse and built a larger bathhouse capable of handling five thousand bathers. The bathing beach now had a frontage of 550 feet. Spackman opened the beach on June 12 and welcomed the first statewide gypsy motorcycle tour. The bikers came from Indiana, Eastern Illinois and Chicago. Then on June 18, more than three hundred employees of A&P had a picnic at the beach. During the season, Ideal Beach had a free motion picture on Sunday nights and concerts with dancing nightly. Some were called "Depression dances," and Spackman charged only a dime to get in. Many more free things were offered to lure in guests.

In 1933, Ideal Beach opened its season with concerts every Sunday evening beginning on March 26. It charged only a dime for admission, which included two dances. Dances cost five cents each or fifty cents for an entire night. After the beach season opened on Memorial Day, dances were held nightly and on Sunday afternoons.

In 1934, Spackman decided to keep prices low because of the Great Depression. An adult season pass cost just a dollar at Ideal Beach. In addition to providing nightly dancing, Spackman brought the Banard Brothers Circus to the beach on June 17. With the economy improving, Spackman decided to increase the size of the casino and go after some nationwide bands. He also built the Roof Garden, which served alcohol on one side and nonalcoholic beverages on the other. A bottle of beer cost fifteen cents, or you could get two for a quarter. Below the Roof Garden were a jukebox and a refreshment stand, where many of the younger Spackmans worked. "It was like a Dairy Queen," said Joy (Spackman) Boomershine Bailey. "We'd make everything there, like splits, sundaes."

By 1934, the economy was improving during, so Spackman began reaching out to more expensive orchestras. He also increased the size of

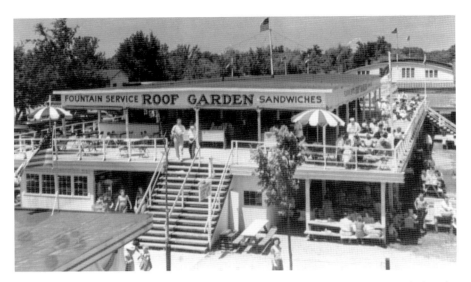

The Roof Garden was built in 1934 and served food and beverages on the upper deck and ice cream below. *Vintage postcard.*

the dance casino. He brought in Johnny Davis and His Orchestra, an NBC coast-to-coast band; the Don Pablo Orchestra and his Fourteen Virginias; Joe Cappo and His Egyptian Serenaders; and Lop Jarman, the world's greatest euphonium player (a conical-bore, baritone-voiced brass instrument). The resort also featured a Battle of the Music Night by having two orchestras play the same night.

Ideal Beach opened on June 2, 1935, for the summer season. A large pier was built at the beach for the season. The dance pavilion was completely redecorated for the summer. The refreshment stands on the roof had doubled in size over the winter. An open-air balcony was planned over the water because of the large crowds the orchestras were bringing in.

During the winter of 1936, an ice jam formed in Shafer Lake and destroyed the pier that was built, so Spackman unveiled plans for a U-shaped steel-and-cement pier to replace it. Ideal Beach held its spring opening of the dance casino on March 29. It was open every Sunday night after that date until the summer opening on Decoration Day weekend. Spackman was busy during the off-season, increasing the size of the Roof Garden. He also built three new cottages that were two stories tall. They were fourteen by thirty feet in size. All the buildings were given a fresh coat of paint. Two large floodlights were added to the beach, as was some Lake Michigan white sand.

Entertainment

Big-name orchestras started coming in 1936, including the likes of "Tiny" Hill and His Band. Tiny was actually very large at 365 pounds and was dubbed "America's biggest band leader." One of the biggest crowds of the year came for Dick Cisne and his twelve-piece band. More than 2,400 paid admissions showed up, and the park ran out of parking spots.

During the winter of 1937, Spackman worked on enlarging the dance pavilion instead of building a new open-air floor as he originally intended. He added 1,200 square feet of dance floor to the north end of the pavilion. The new section would have a roof that could be rolled back on warm evenings to leave the new floor entirely open to the air. This was in the days before air-conditioning. The old orchestra pit was torn out, and a new one was installed on the west side. A second portable orchestra platform was planned for the north end of the dance floor. The improvements would double the size of the dance floor. One of the first orchestras to play in the renovated Casino was Eddie Cantor and His Orchestra in May. Cantor was a singer, actor and radio personality. He had performed in the Ziegfield Follies. Then Duke Ellington and His Orchestra came to play later in the summer. The Black musician had become famous in the Roaring Twenties by playing at the Cotton Club in Harlem. Ellington would go on to become very famous and earn a dozen Grammy Awards. Al Katz and His Kittens came directly from the Arcadia Ballroom in New York City to perform on July 29. The Kittens were women singers.

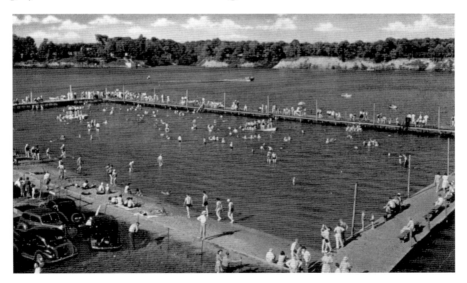

The new swimming area at Ideal Beach was first enclosed in 1936. *Vintage postcard.*

In 1939, the beach didn't open for the season until May 29, with dancing and music provided by Kaye Jones and his fourteen-piece orchestra. Many beach improvements, including one hundred more truckloads of sand, were made to the beach. The bathhouse was renovated and made larger, new walks were put in, new tables were added and a new roller skating rink was added between the Roof Garden and the bathhouse. Spackman advertised that his park could now handle up to five thousand swimmers.

In the summer of 1941, Ideal Beach brought in five rides—a Ferris wheel, a loop-o-plane, a merry-go-round, a tilt-a-wheel and a chairplane—from Miller Amusement Enterprises to entertain guests during the Memorial Day weekend. The beach also provided fireworks on June 1 as part of the weekend. And Mike Kelly made a famous ride through fire. Ideal Beach also introduced some new attractions during that summer. V.W. Schumacher built a double-decker ferry boat called the *Fairy Queen*. The forty-six-foot-long boat was ready by the Fourth of July to provide cruises around Shafer Lake. Also new to the beach was the moto-scoot track with banked turns. The go-cart track was operated by Bob Sangster. The bathhouse was enlarged as well. On the beach, a new toboggan ride was introduced. Tom Spackman began showing free talking movies and two short films on Friday nights beginning on July 10.

While the world went to war in the early 1940s, Spackman continued to bring in big orchestras to entertain his guests. The most popular orchestras that came to perform at Ideal Beach included the Glenn Miller Orchestra, rated number one by several nationwide polls; Benny Goodman, dubbed the "King of Swing," and His Orchestra; Tommy Dorsey and His Famous Orchestra; Les Brown and Famous Band of Renown; and Eddie Howard and His Orchestra.

Since many orchestras lost members to the war effort, Spackman was forced to cut back on the number of bands he could host at the Ideal Beach. In 1943, Spackman also had a hard time getting meat, sugar and other food items for Ideal Beach, so he was limited in what he could offer beachgoers.

The old wooden pier was damaged by an ice dam during the winter of 1944, so a new cement pier was constructed around the bathing beach.

Near the end of World War II, Earl Spackman stepped down from the beach's board of directors and turned the reins over to his son Tom. The following year, Earl passed away from a heart attack while on vacation in Canada.

Entertainment

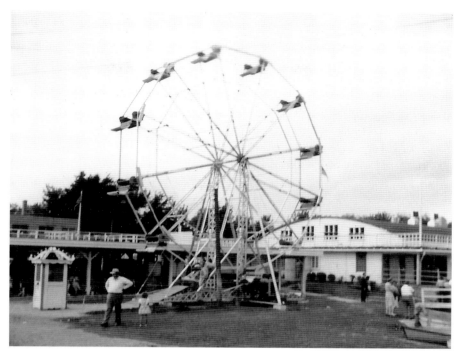

Above: Amusement rides first came to Ideal Beach in 1941. *Vintage postcard*.

Left: Tommy Dorsey autographed this photograph of him. His band appeared at Ideal Beach several times. *Courtesy Ruth Spackman Davis*.

The Ideal Beach Hotel was first built in 1951. *Vintage postcard.*

Spackman purchased Meredith's Place in April 1946. It was located north of the ballroom. This added to the number of cottages Ideal Beach had to offer.

In 1950, Ideal Beach held some boat races beginning on April 1. The first was a college sailing boat regatta. About fifty boats participated from four colleges: Purdue, Notre Dame, Indiana University and DePauw. The official summer opening of Ideal Beach came on May 26, with boat races that were sponsored by the Monticello Jaycees. It was the first official American Power Boat Association race, and more than sixty boats competed. Also at Ideal Beach, Hugo Butler opened a new miniature golf course. A new Beach House Hotel opened at Ideal Beach. It had twenty-five rooms that were air-conditioned. A new marine supply and service store opened there as well.

In 1951, a new $100,000 hotel opened at Ideal Beach, with forty-two rooms with air-conditioning. The beach's first antique auto show was held over two days—June 9 and 10, 1951. The owners of the cars were made overnight guests of the park. The oldest car on display was a 1904 Oldsmobile. The event became an annual affair, with about one hundred automobiles attending.

Ideal Beach became Indiana Beach in 1952. The park started to switch from a beach with a dance hall to more of an amusement park. The beginning of the rock-and-roll era in the 1950s also spelled the end of the big band era at the park.

ENTERTAINMENT

ROLLER SKATING RINK

Monticello once had a roller skating rink. The building was constructed in 1978 on Fishers Street and operated as Roller Junction until the beginning of the twenty-first century. Then it went out of business. "I grew up at the skating rink in the '90s where the golf cart place is now," recalled Lucy Dold. The rink was run by Mr. Puterbaugh. The building is now owned by GTC Holdings LLC.

THEATERS

White County has had its share of theaters, but only two remain, and they are both in the county's largest community, Monticello. Call it progress or a sign of the times—the first public motion picture theater opened in the United States on June 19, 1905, and it was called a nickelodeon.

Burnettsville

Burnettsville had the Cosmo Theater in the 1910s, and it played movies on Thursday, Friday and Saturday evenings. It showed silent movies.

Monon

The first nickelodeon opened in the county came in 1905 in Monon. It was an open-air theater on the roof of a building at Fourth and Market Streets. Owner Harley Hornbeck later moved it to 109 South Market Street and changed its name to Lyric Theater. The Arc also operated in Monon on North Market Street. Then the Majestic Theater opened in Monon in 1912.

Herb Tull purchased the Lyric from Hornbeck and changed its name to the Strand in 1926. When talkies came in the late 1920s, he had to make a major investment to upgrade the equipment in the theater. A fire in 1937 destroyed the Strand, so Howard had to start all over again.

Howard constructed a new building on North Market Street and named it after himself. The theater did good business for quite a while and then started to run into trouble. Gerrie and Lexi Baer bought the Monon Theater on October 2, 1992. They had operated the Twin Lakes Cinema in Monticello

for three years prior to that. The couple put a pop-art museum in the lobby. It contained thousands of rare items that documented the history of the film industry. The theater closed in 2005, as the couple went to work at a theater in Rensselaer.

The Monon Civil Preservation Society purchased the building in 2013 for $13,000 and is now in the process of restoring it at a cost of more than $1 million.

Monticello

The first theater in Monticello was an opera house. Mr. Carson was preparing to build an opera house north of the public square at the site of Mikesell's Livery Stable in May 1895. However, in July, he moved its location north of the square in the old Wilson lot. He took on a partner, Mr. Holtam, so the opera house was built by Carson and Holtam a few months later on the east side of South Main Street. The opera house operated until the men sold it to Hornbeck Amusement Company of Lafayette, which renamed it the Strand Theater in 1917. The Strand was a franchise that stretched across America. The theater was owned by the Hornbecks. Even after the opera house became the Strand, it sometimes held plays, like *Oh, Oh Cindy!* in 1921. The Strand Theater had a visit from actress Ruth Stonehouse in November 1921. She had been in many silent movies since 1911 and later became a director.

The nickelodeon was the first type of indoor theater to show projected movies. The phenomenon reached Monticello in 1908. Two nickelodeons began operations in the town: the Arc and Electric Theaters. Of course, it cost just a nickel to get in, hence the name. They both showed silent movies. The Electric Theater didn't last long, but the Arc continued into the next decade. By 1913, the Arc had raised its prices to a dime, so technically, it was no longer a nickelodeon. It also brought in vaudeville acts, which included musicians, singers, dancers, comedians, trained animals, magicians, ventriloquists, strongmen, et cetera.

Also in 1913, Hornbeck Amusement leased a store to create the Lyric Theater, which opened in April on North Market Street. The Lyric Theater also opened a theater on the north side of the town in May 1921 at 224 North Main Street, giving the city a north and south side theater. The southern theater featured beautiful paintings by a Chicago artist in the lobby and a five-piece orchestra. The theater's first movie was *Hands Off*, starring actor Tom Mix.

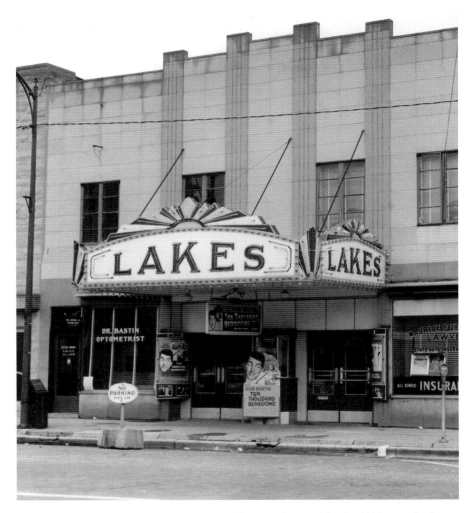

The Lakes Theater opened in 1933. The building was damaged by the 1974 tornado that hit Monticello, and it was torn down. *Cinema Treasures photograph.*

In April 1924, R.A. Shobe of Kentland bought the Strand and Lyric Theaters from Hornbeck Amusement. Shobe held on to the theaters for only four years and then sold them to Cary and Alexander of Lebanon in July 1928. That firm already had four other theaters. The Strand burned down on January 5, 1933.

Cary and Alexander opened the Lakes Theater on November 10, 1933, at the former site of the Strand. The first movie shown was Cecil B. DeMille's *This Day and Age*. The new theater featured a built-in sound

system, indirect lighting, carpeting and an illuminated fountain with a rock background in the foyer.

On November 17, 1943, the Lakes Theater hosted a play, *This Is the Army*, an Irving Berlin production. The play portrayed World War I, with actors playing soldiers and an orchestra providing music.

The Lakes Theater was damaged by the 1974 tornado on May 3 and didn't reopen until June 25 that year, but it closed a year later. After a year-and-a-half-long absence, the theater was bought and reopened by Roger Vore of the Vore Cinema Corporation. The front of the building was demolished, and an alley was created to lead to the entrance of the new theater. Vore then put a wall down the middle of the theater to create two theaters in one building, so he could show a movie in each theater, making it a duplex. Vore renamed it Twin Lakes Cinema. He ran into financial trouble and went bankrupt in October 1981, so he closed the theater and later sold it to Chuck Ryan in 1982. Ryan turned it into a "dollar house" in October 1983 to increase attendance. He sold it to Tim and Jacque Luby in 2005. They put it up for sale after the COVID-19 pandemic and sold it on July 31, 2023, to Ryan Harrison and Ryan Crawford of Winamac. They have renamed the theater the Peacock Theater and plan to go to one screen and a stage in the future.

In 1948, the Monticello Drive-In Theater was built on the north side of the city, and it opened the following year. The original owners were Mr. Rickey and Mr. Taylor. They later sold it to Morris Breazee in 1961. Longtime employee John Eubanks bought the theater from Breazee in 1985. Eubanks sold the theater in 2001 to Earle and Phyllis McLaughlin. They decided to change the theater's name to Lake Shore Drive-In Theater and added another screen. They call it a "dinosaur" but still operate it today from May to September.

Wolcott

The Wolcott Movie Theater was built in the 1940s on Range Street and opened on March 11, 1948, showing the western *Albuquerque*. Arthur Herzog opened the theater and sold it to Kenneth Barnard in 1952. Then Allen Thayer bought it in 1959 and added a coffee shop. The movie theater showed movies only on the weekends after that. The theater quit showing movies, and owner Walt Owens now uses it to house the Wolcott Theater Café.

ENTERTAINMENT

Free movies were also shown in other places in the county, including Little's Café in Chalmers and People's Co-Operative Store in Monticello in the 1940s. Movies were also shown in downtown Reynolds in the 1940s, and people could purchase popcorn at a stand or sodas from a local drugstore.

RADIO STATIONS

White County has lost a couple of radio stations in its history. The first radio station in the county was WVTL, which stood for the "Voice of Twin Lakes." Located at 95.3 on the FM dial, the station was started by Joe and Pat Sweeney at 115 North Main Street, above Holder Pharmacy. In 1970, they built a structure on U.S. 24, west of Monticello.

The Voice of Twin Lakes became popular after the tornado hit Monticello on April 3, 1974. "It came to fruition after the tornado," explained Bill Diebel. "We had no telephone service. It was an interesting time. It stayed on all the time."

The station broadcast news and information that was valuable, considering what the city had gone through. Diebel started working for the station in 1977 and stayed for about five years. He said the station was sold to two brokers and moved to Chalmers to get the Lafayette market.

The next radio station to come to Monticello was WLZR. The Laser was started in 1985 and was located at 204 North Main Street. It didn't last very long and was replaced by WKJM Magic 95 the following year. That station lasted only two more years.

Then Diebel began his own radio station—WNJY, 102.9 FM—in May 1989. It was located at 302 North Main Street. The station was licensed in Delphi, but it broadcasted from Monticello and Delphi. Diebel recalled the first song played: "Gary Baer played the theme song to 'Welcome Back Kotter.'"

The station started out with a funny thing that nobody thought would work—color weather radar. How can you see color on the radio? Well, you can't, but the radar was on top of the station, and it showed the different areas of weather in color, so the station could broadcast that on the radio. No, you couldn't see color on radio, but you could visualize it through the words spoken. "It was very, very successful," said Diebel. "It was continually sponsored for years."

The station first played the oldies from the 1950s, 1960s and 1970s. When it began playing music from the 1990s, it dropped the 1950s and played some hits from the 1980s.

The station also broadcasted a lot of high school sports, as it covered the four high schools in White County and the two high schools in Carroll County. Tom Mohler and John Westfall broadcasted football games, and the baseball games were primarily covered by Rich Anthony and John Soloman. Diebel said Soloman won broadcast awards twice during the time he owned the station.

"I think I had a crack team without a doubt," said Diebel.

Diebel's radio station lasted a decade before it was sold. Then the station moved to Lafayette.

The only remaining radio station in White County is WMRS, which was started on March 13, 1989. "The tower used by us is now used by them," said Diebel. Kevin Page and his brother-in-law, Bruce Quinn, started the station now located at 132 North Main Street. Page passed away during the COVID-19 pandemic, and the station is now run by his wife, Laura, and daughters, Brandi and Jamie.

TRACKS

Two types of tracks have been lost in White County. Two were for horses and the other was for cars.

A horse racetrack existed at the fairgrounds on the west side of Monticello in 1878. The Monticello Turf Association ran its first annual race on August 14 and 15, 1878, with $800 in prize money. Races of a half mile and mile were run. Irvin Greer was the association's president, and Jeptha Crouch was the superintendent. On August 14, the Maid of Richland won the running race. Sleep John won the pacing race, and Monticello Maid won the trotting race. The next day, Little Wonder won the trotting race. The Maid of Richland again won the running race. This was the first and last time the races were run, as no record of their running again was found in the newspapers.

A racetrack was also located across the Tippecanoe River from Monticello in the late 1800s. The area is now filled with homes and is known as East Monticello.

The other horse track was a harness racing track, part of the Wolverton farm on Chalmers Road. The Wolvertons were known for racing trotters and competed throughout central Indiana. The farm belonged to Phillip Wolverton. The track was lost when parts of the farm were inherited or sold off over time. The huge Wolverton barn is also gone.

Entertainment

Bill Tyler was one of the racers at the Monticello Speedway with his Monticello Machine Shop #84 car. *Bill Tyler photograph.*

This was the concession stand for the Monticello Speedway. The Monticello Christian Church can be seen in the background. The building has since been removed. *W.C. Madden photograph.*

Big horse shows were popular in Monticello and Chalmers more than a century ago.

In the 1950s, many communities had car racing tracks, and the Monticello Speedway was constructed by Gail Britton on the south side of the city on land that was once owned by Claude Ellis. Construction started in 1950, and the track held its grand opening on April 22, 1951. A quarter-mile oval track was built with bleachers and a concession stand. The track could seat 10,724 fans. The dirt track featured stock car races, figure-eight demolition derbies and local drivers competing for a little cash and some fun.

The short track was best described by a former driver there, Charlie Snow, or "The Big Drift," as a track announcer nicknamed him: "No sooner than you did a curve, the next curve was coming up fast. "

Bill Tyler Jr.'s nickname was "Wild Bill." "That was a good dirt track," Tyler said. The driver said that some famous drivers raced there before they became famous, including A.J. Foyt and Tommy Bettenhausen; they both raced there before driving in the Indy 500.

By 1955, the track was closed. In its last season, it was used for other things besides racing. Wrestling matches were held there, and admission cost a dollar. A Joe Mix Circus came there and charged only fifty cents for admission.

The land was later sold to Monticello Christian Church, which build a new church there in the late 1960s. For a long time, the old concession stand stood by the southwest corner of the church until it was recently torn down.

9

ORGANIZATIONS

Some of the nonprofit organizations that were started in the 1800s began dying off in the 1900s. Such was the case with organizations like the International Organization of Odd Fellows, Knights of Pythias, Indiana Masonic Lodges, et cetera.

A few organizations that existed nationwide were also present in White County. One was the infamous Klu Klux Klan. The KKK was very strong in the 1920s and had a local group in White County. The Klan first came to the county in March 1921, trying to recruit members. It was successful in organizing local Klan groups throughout the county.

The Klan burned a cross in April 1923 in Burnettsville, and its public demonstration was caught on film and published in the *Burnettsville News* on April 16. A cross was erected at the south end of Main Street and fastened to the iron hitch rack at Millard Hildebrand's residence. The pine cross was wrapped in burlap and soaked in kerosene. Members of the secret society wore white uniforms or costumes that covered their faces and heads to disguise their identities.

The KKK also spoke to Monticello residents on April 25 at the bandstand by the county courthouse. And they marched through town with signs that read: "White Supremacy," "Pure Womanhood," "We Want Professional Teachers in Public Schools," et cetera. Then the group held another parade and band concert in May that attracted thousands because it was free.

The Klan also held a meeting in Reynolds on May 25, 1923. It then held a parade of the women of the KKK in Monon on July 11 that year. In

The *Herald Journal* newspaper published this issue on August 24, 1978, for the Society of Old Settlers. *Courtesy Monticello Herald Company.*

September, it held a Klan Day at the Brookston Exposition. And in October, another parade was held in Monticello.

In October 1925, the group leased space in Monticello. It even listed its phone number in the 1925 Monticello telephone directory under "W.C. Klan, 236½ North Main Street." The 350 members of the Klan held a

ORGANIZATIONS

homecoming and dedication at their meeting room that was formerly occupied by the Monticello Masonic Lodge.

However, the group's popularity quickly changed in 1926, and the organization went underground. While the Klan may still exist, it is more clandestine now. No evidence of it in the county has appeared since the Roaring Twenties.

The oldest countywide organization that existed until 2000 was the Society of Old Settlers. The organization started meeting unofficially in 1858. The first Old Settlers Day was held on August 16, 1872, and the society was founded the following year and held its first celebration on September 25, 1873. Its last celebration was held on August 12, 2000, and it was the group's 127th such celebration. Vernise Carlson of Monticello was recognized as a 100-year resident of the county and was presented with the Umbrella Award. Merle Davis of Burnettsville was presented the Cane Award for being in the county for 85 years, 3 months and 5 days. Mayor Bob Fox was the speaker at the event. The turnout was low, so the group decided to disband. It turned its records over to the White County Historical Society. The last president of the society was Robert Wilcoxon.

BROOKSTON

The Knights of Pythias, a fraternal organization and secret society, was formed in Washington, D.C., on February 19, 1864. Lodge no. 289 was formed in Brookston in 1901, according to markings on a building there. When the organization there died is unknown. It was listed in a 1928 telephone directory.

IOOF Lodge no. 164 began operating in the town in the late 1800s. Then Rebekah Lodge no. 641, a women's associate group of the International Order of Odd Fellows, began operating there on October 30, 1902. Neither group still exists.

Masonic lodges in White County have disappeared, except for one in Monticello, Libanus Lodge no. 154. Brookston was once home to Masonic Lodge no. 66, and it had a building located on North Railroad Street. The lodge was moved from Pittsburg in Carroll County to Brookston in 1857. When it ceased operations is unknown. The current owner of the building, Matt Irvin, now runs an appliance rental place out of the building. He said that the building was moved from Philadelphia to Monticello by the railroad in 1885.

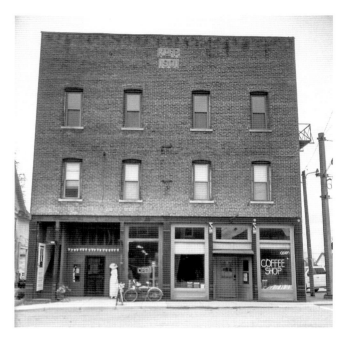

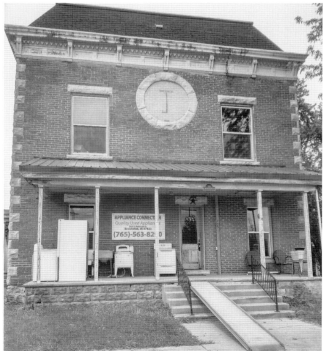

Top: The Knights of Pythias constructed this building in 1901. *W.C. Madden photograph.*

Bottom: The Old Masonic Lodge building in Brookston now belongs to Matt Irvin. *W.C. Madden photograph.*

ORGANIZATIONS

BURNETTSVILLE

The Free Masons moved Lodge no. 66 from Pittsburg in Carroll County to Burnettsville in 1857.

The small town also had an IOOF Lodge with nine members formed there in September 1898. The IOOF Lodge was disbanded in the late 1940s, and its members fled to the Monticello and Logansport lodges.

Burnettsville Lodge no. 663 of the Indiana Masons was formed on December 31, 1904, also with nine members. The lodge was closed in 1995 and was absorbed by Royal Center Lodge no. 585.

The Knights of Pythias had a lodge in Brookston in the 1920s, as it was listed in the 1928 telephone directory. Membership had grown to 325 members by 1949. The last newspaper account that could be found of the association came from 1988, when the group met at Angler's Restaurant for a banquet. Exactly when the group ended is unknown, but according to Joe Weiss, it wasn't in existence in 1992.

MONON

The Knights of Pythias Lodge no. 196 once existed in Monon.

MONTICELLO

The Knights of Pythias Lodge no. 73 was organized in Monticello on October 29, 1877, with twenty-five members. It was last listed in the Monticello telephone directory in the 1920s but has since died off.

In 1945, the Monticello Masonic Lodge organized the Rainbow Girls, because back then, there were few activities for girls in schools. None of the high schools had sports for girls. The International Order of the Rainbow Girls was for girls aged eleven to twenty-one. The organization was started in the United States in 1922. The girls helped with projects for Eastern Star, the women's arm of the Masonic Lodge. "They helped serve dinners and clean the lodge," explained Dorothy White. "They were treated with ice cream socials and a formal dance at the [Tippecanoe] Country Club." When White quit being the advisor, someone else took over the group and swindled it. "After [the new advisor] walked out, we found out she owed money everywhere." So, White took over as the advisor again until the

125

The Moose Lodge was located just outside of Monticello. *W.C. Madden photograph.*

organization died out in 1988. She said it died out because the girls were more involved in school activities, such as sports. Rainbow Girls is still active.

The Monticello Business and Professional Women's Club existed in the 1940s and 1950s. Then there was the Optimist Club, a worldwide volunteer organization.

The Moose is a fraternal organization that was first founded in 1888 by Dr. Henry Wilson. Moose Lodge 906 was established in Monticello a long time ago and died out a few years before the publication of this book. Its lodge was located at East 150 South Street on the southwest side of the city. The group built the lodge in 1973, and it was sold in 2020 to Woodshed Properties for $110,000.

The Jaycees, also known as the Junior Chamber, is a worldwide community of young active citizens between the ages of eighteen and forty. It is a leadership and training organization, service organization and civic organization. The Jaycees formed a lodge in Monticello in the 1940s. The group had a building on Third Street, where it met. In 1974, the Monticello Jaycee basketball team won a state championship. The group was very active until the late 1900s.

While many people lost their lives in the recent COVID pandemic, many organizations were lost to the pandemic as well. For example, the

Organizations

The Jaycees had this building on Third Street in Monticello. *White County Historical Museum photograph.*

The Greater Monticello Chamber of Commerce was housed in this office on North Main Street until it moved to West Broadway Street. The building was replaced by a statue of Colonel Isaac White on Constitution Plaza in 2015. *W.C. Madden photograph.*

pandemic ended the days of the nonprofit Greater Monticello Chamber of Commerce and Visitors Bureau. Before the pandemic, the Monticello Chamber had thrived. It had two full-time employees. Janet Dold was the executive director and had worked in the position for many years. When the pandemic hit, the chamber could no longer hold its annual fundraising golf tournament, Christmas in July. The event was so popular and the group had so many signups that it had half the golfers tee off in the morning and the other half tee off in the afternoon, with lunch served for all the golfers in between. It was the largest scrabble tournament in the county. The tournament continues today, but it is sponsored by the Streets of Monticello Association.

REYNOLDS

The Knights of Pythias organized Lodge no. 454 in Reynolds on February 10, 1898. It lasted into the 1950s, but it no longer exists.

The town had a Lions Club for a short while. It was organized in August 1946 but was disbanded six years later on June 30, 1952.

OTHERS

Many other organizations have come and gone in the county over the years.

In the early 1900s, the Lady Macabees, January Club, the Guild, Royal Neighbors, Modern Woodmen and Elmore Concert Band existed in the county.

Then came the Commercial Push Club and the Young Ladies Business and Social Club, which existed in the Roaring Twenties.

Business Network International was active in the county in the early part of the twenty-first century.

The Lake Freeman Civic Association was first organized in 1940 and had members from both Carroll and White Counties, since the lake is split in two by the counties. Its first meeting was held on May 10, 1941, and more than one hundred individuals paid one dollar to join. Initially, the association met at the City Park. The following year, the association created two hatchery ponds at the City Park.

The latest loss is that of the Monticello Lakes Resort Association, which decided to disband in August 2023.

10

MANUFACTURERS

Manufacturing began coming to White County around the 1850s, but these companies were relatively small compared to today's manufacturers.

One of the first large factories in the area was the Monticello Thread Factory, which opened along the Tippecanoe River in the late 1800s. In the early 1900s, it was sold and became the Chicago Thread Factory. Then it was doubled in size. The factory increased production in 1914, when many European factories closed due to World War I. It was later sold to Marshal Fields, which moved the operation to another state.

The building was then taken over by Bryan Manufacturing in April 1944. The plant began making electrical wiring assemblies for the war effort. Women employees outnumbered men five to one, as many men went off to war. Business was so good that the company built an addition in 1950. The manufacturing building was partially damaged by a tornado on April 3, 1974. The powerful twister knocked down a wall on the east side of the factory, trapping workers and killing Peggy (Good) Durham from Monticello. Others were injured as well. The company recovered from the damage and lasted until 1980, when it closed, leaving two hundred people without jobs. The old building was taken over and became a pallet-making facility. It burned to the ground in a massive fire in 2008.

A century or more ago, just about every community had a tile-making company to produce field tiles for farmers. Back then, farmers would put down clay field tiles to improve the drainage system in their fields.

Left: All that is left of the old Chicago Tread Factory is this stone from the building, which now sits at the White County Historical Museum. *W.C. Madden photograph.*

Opposite: This lake in Wolcott was formed by the Wolcott Brick and Drain Tile Company in the mid-1900s. *Dorothy Salvo Benson photograph.*

Several communities had tile factories, including the Monticello Cement Tile Factory, which was started in 1910 and was located at 602 South Illinois Street. Chalmers also had a tile factory.

The Wolcott Brick and Drain Tile Company was also started about one hundred years ago, and it left behind a beautiful block of homes surrounding a small lake filled with fish, ducks and geese, creating a picturesque scene in the community. The lake itself is more like a pond, except for the water reaching a depth of more than twenty-five feet. The area represents a vital source of growth for the economic development of the rural community. The town's founder, former United States senator Anson Wolcott, developed a tile mill in the area in the early 1860s. The mill produced building and drain tiles. The Gerard brothers purchased the mill by trading their farm to Wolcott. The mill was successful, turning out four thousand tiles per day. It continued to change hands over the years, and eventually, the making of brick was added to the mill. The Wolcott Brick and Drain Tile Company decided to sell lots around the new lake in 1964. The residents and wildlife have enjoyed the area ever since.

Nowadays, field tile has been replaced by large plastic tubes buried three to five feet in the ground. The perforations in the tubing pull water that isn't bound to the soil. The tubing is produced by large manufacturers.

Also about one hundred years ago, there was a gravel company up in Buffalo. Today, the only quarry in the county is located in Monon and run by U.S. Aggregates.

The Attire Manufacturing Company existed at 502 South Railroad Street in Monticello until 1924, when Reliable Garmet Company took it over. It

manufactured "Monticello overalls." Attire then moved its operations to the second floor of 210 North Main Street. The building was destroyed by the April 3, 1974 tornado that hit Monticello.

In the 1930s, the Ladoga Canning Company and the White Beverage Company were in operation in Monticello.

In the 1940s, the Ashlock Cabinet Company opened in Monticello. It was owned by Norwood and Mabel Ashlock. Mabel was a descendant of Confederal general Robert E. Lee. The company was closed around the turn of the twenty-first century, according to a descendant.

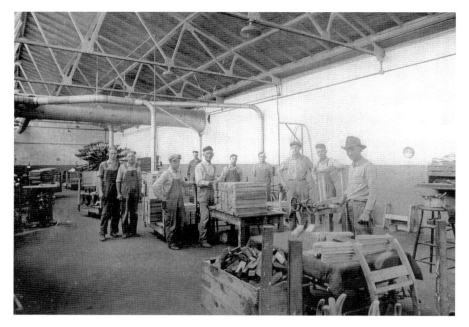

Above: Workers at Rider Furniture were busy at the company in the 1930s. They were kept busy when RCA took over the plant in the 1940s. *White County Historical Museum photograph.*

Opposite, top: RCA employed more than one thousand people at this plant in Monticello for more than forty years. *White County Historical Museum photograph.*

Opposite, bottom: The Cheesborough-Ponds Company occupied this building on Sixth Street in the 1960s. The building is now used by Carroll White REMC. *White County Historical Museum photograph.*

The Rider Furniture Company operated in Monticello in the early part of the 1900s. Besides furniture, it made wooden body sections for the Crosley station wagons in the late 1930s and early 1940s before it went out of business.

Rider Furniture was sold to the Radio Corporation of America in 1941. RCA changed the company's name to Monticello Cabinet Company. That name stuck until after World War II when it became RCA. "My father worked there when it opened," said John Euclid. "He got fifty cents an hour." Euclid's father's name was John as well, and he was an electrician.

Like his father, John went to work at RCA in the mid-1960s. "I got $1.47 an hour," recalled John. He said that RCA had about 1,400 workers when he worked there. RCA was in its glory days during the 1960s and 1970s, turning out about one thousand cabinets a day.

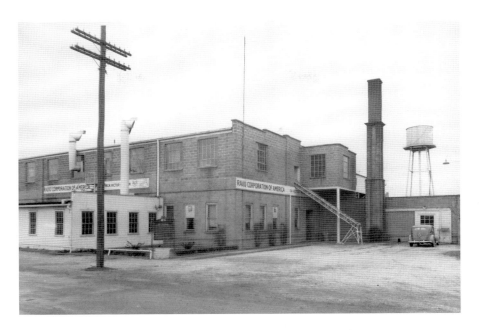

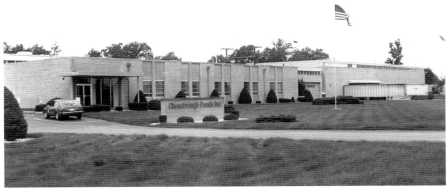

RCA closed its doors in Monticello on July 22, 1982, putting 850 workers out of work. "You could see the writing on the wall a few years before," said Ron Garbison. The company moved its operations to North Carolina.

In December 1985, Dave Jordan purchased the old RCA building and started making patio furniture there. He founded Jordan Manufacturing Company Inc. in the basement of his home in Peoria, Illinois, in 1975. A devastating fire claimed the building in 2005, so he built a new facility on South Sixth Street. At the end of 2011, he added onto his warehouse and modernized his business with new equipment. He turned the operation over to his daughter Ashley Budd in 2021.

Tru-Flight, which was started by Harry Cole, moved to Monticello in 1949. Then Ray Gooding purchased the company in 1968. The company moved to its current location on South Freeman Road in 1984. Then in 2002, Tri-Flight merged with Easton. "Easton was one of our suppliers," explained John Gooding, the managing director at the time. The Tru-Flight name faded away, and now the company is known as Easton and is part of the archery division of Easton-Bell Sports Inc. The company employs about sixty full-time employees and forty part-time employees.

The Cheesborough-Ponds company, a distributor of cosmetics founded in 1955, dedicated its Monticello business in May 1962. Ten years later, the company built another addition on the building. The company decided later to move to Mexico. The building is now occupied by Carroll White REMC.

Harnischfeger Industries built an electric plant on Sixth Street in 1964. The company manufactured and sold material handling and mining equipment. It built an addition onto the plant in 1967. However, the company later moved.

Alloy Rods came to Monticello in 1964. Located on North Sixth Street, the company was in the metal welding market and welded farm machinery, construction equipment, mining machinery and railcars. The company blamed an economic slump for its demise in December 1985, putting 155 people out of work.

Midwest Hanger Company opened in 1971 in the Industrial Air Park at the White County Airport. By May 1972, the company was in full production, with eight employees on two shifts producing sixty million hangars a year, according to the *Herald Journal*. The company had other locations and was bought out by CHC Industries in August 2002.

The Bassett Rotary Tool Company began operations in Monticello in the 1970s. Located at 710 West Fisher Street, the company transferred ownership to Greenfield Industries on September 11, 2003.

McGill Manufacturing was in business until about 2011, when it was sold to Emerson Manufacturing, according to Dan Whiteman, who worked for the company for eleven years. Emerson owned the company for a while before selling to Regal-Beloit America, now at the same 705 North Sixth Street location in Monticello. The company specializes in building electric motors and other electrical parts. About 145 employees work at the plant, a branch location.

The old Alloy Rods building was taken over by Bev-Pak in April 1988. Tom Moran was the company's founder. The company first made steel cans and switched over to aluminum in the next decade, according to former employee

Bill Vaughn. Dick Woods and Rich Grimley took over the operation in December 1990 and ran it until 1993. Then Reynolds Metal took over until 1998, when it was sold to Ball Metal Beverage Container Corporation.

While Monticello has been the center of most of the manufacturing in the county, Monon has been the center of the area's trailer business for a long time. Keith Jackson, who owned a machine shop in nearby Francesville, established Monon Trailer in the town in 1952. The company manufactured trailers for semitrucks to haul. In the mid-1970s, Monon Trailer was sold to Evans Products and continued to run under the Monon Trailer name. Victor Posner, a pioneer in asset stripping and leveraging buyouts, purchased Evan Products in 1983 and sold off the company's assets to pay off the debt from its buyout, which included Monon Trailer. Monon Trailer experienced decline after its upper management left and formed Wabash National in Lafayette in 1985. The company remained in business until 1988, when it went bankrupt. The HPA Monon Corporation took over, and at the peak of its employment, the company had 1,180 employees. In May 2003, the corporation closed its doors and sold out to Vanguard National Trailer Corporation. At the time of the sale, the fifty-one-year-old plant in Monon comprised ten buildings on three hundred acres. Vanguard continues operations today.

Mack and Company Ice Cream and Bottling Works constructed a building at 314 North Market Street with the intention of building a manufacturing company. McPherson and Fairchild were in the business of manufacturing bottling, selling and distributing glass bottles, carbonated beverages, soda waters, ginger ales, cider and artificial and mineral waters in 1913. The business prospered, and in 1924, the company built an ice plant next door. The ice plant made three hundred pounds of ice daily for the benefit of its bottling plant and to provide ice for the Monon community. In 1936, Biederwolf Ice Company from Monticello bought the Monon Mack and Company Ice plant and moved the equipment to its Monticello plant. The building became a garage. The location of the bottling plant later became the Monon Coca-Cola bottling plant, employing area residents and leaving wonderful memories to those who passed by the large windows, witnessing the movement of the passing bottles.

11

RESORTS

In 1923, Shafer Lake, now called Lake Shafer, was formed after the Norway Dam was completed. The newly formed lake provided the opportunity for resorts and other businesses to be built and within a few years.

Then in 1926, Earl Spackman created Ideal Beach, a place where people could swim, rent a boat or enjoy something from the concession stand. By the 1930s, Spackman had added a dance hall, amusement rides, a passenger boat and other attractions. Entrepreneurs decided to take advantage and build some resorts, cottages, RV parks and other places for people to go to rather than go to Ideal Beach.

One of the first was Butterfield Camp, which was opened in 1930 and located on the northeast side of the Big Monon, which fed water into the lake. H.A. Butterfield of Harvey, Illinois, was its owner, and it was managed by Mary McClure. Then Roy Baker and his wife began running it in 1941. By 1950, it had eleven cottages and was run by Ralph Johnson. The camp also had a pool, playground, campground for trailers, tents, bait, boats for rent and a pool. "That pool was filled with well water, so if you went at the beginning of season, it was really cold," said Carol Thyfault. A white picket fence divided the shallow end of the pool from the deep end. Debbie Elmore Vandervort remembers going to the store there for an ice cream and a Zero bar as a child.

Bailey's Lane Cottages first opened in 1933 on North Untalulti Drive. Its name was later changed to Anchor Bay Resort, and it is currently owned by Patriot Resorts LLC.

Resorts

This vintage postcard shows Butterfield Camp, which was opened in 1930. *White County Historical Museum photograph.*

The Bayside Resort was built in 1940 by Marvin and Edna Provo on Indiana Beach Road. In 2005, Brian and Sandra Kearney sold the resort to Terry Coffin, according to White County property records. Coffin sold it in 2018 to Diversified Ventures LLC, which changed the name to Alexander's Landing. Today, the resort is named Shafer Lakeside Resort.

The Bay Point Resort was located at the head of Indiana Beach Road. It was last owned by Mike and Marty Scheurich until it was purchased by Keli Jennett in 2018. She renamed it Dockside Lake Resort. She sold it to Jennifer Ousley in June 2023.

Babcock's Resort was owned by M.E. Babcock and was located north of Indiana Beach. It had eight cottages.

Barekman's Lodge was owned by Homer H. Barekman and was located on the east side of Lake Shafer, nine miles north of Monticello, near Buffalo. The lodge had three cottages.

Bea's Lakeside Cottages was constructed in 1946, the year after World War II ended. Seven cottages were built at that time. Bea also built a small store on Lake Shafer, across the street from the cottages. She had boats and motors for rent on the lake. The cottages were purchased by Adam and Amy Anderson in 2005 under Lakefront Enterprises LLC. The Andersons sold the property to Loretta Lord in 2015. She transferred it to Daniel Dumoulin in 2019, and it became a restaurant, which is now called El Lago Taco and Tequila Bar.

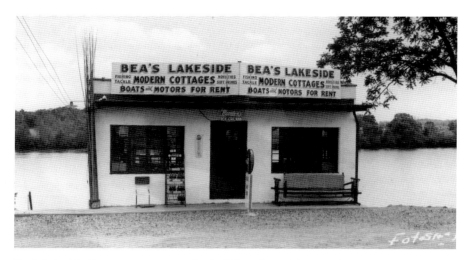

Bea's Lakeside Cottages constructed this building where visitors could rent boats and motors on Lake Shafer. The building has since been renovated and is now home to El Lago Taco and Tequila Bar. *White County Historical Museum photograph.*

Big Chief Lodge had seven cottages and four motel-type rooms for rent. Located on Indiana Beach Road, it was first constructed in 1928. Gale High's parents purchased the resort in the 1950s and owned it for almost half a century before selling it in 2002. The resort had seventeen suites for rent, as well as three cabins. High sold it in 2008 to David and Usa Adkins, and it became Neon Bay Resort. They sold it to Our Little Venture LLC in 2021.

The Clearview Resort was once located on Indiana Beach Road and was owned by Jim and Judy Bowman. The Commadore Cottages existed in the early days of the lake.

The Commadore Cottages existed in the 1930s and were located on Lake Shafer.

Dave's Modern Cottages opened near White's Point in 1937. It was run by Dave Sangster and his wife. In 1948, H.S. Sowers purchased the resort. By 1950, it had seven cottages for rent.

Dawn's Resort was located on Indiana Beach Road and had nine cottages.

Frank's Lodge was established on the east shore of the Big Monon Creek in 1929 by Frank Fiala. In 1932, he oiled the road to create access for customers. The following year, Fiala created two flowing springs and a well at the resort so that people could take jugs of fresh water with them. In 1938, the Clarence Fee family became the new owners of the property. They owned it for a while before selling it to Herman Gatewood. Then

it changed hands again, and this time, it was purchased by Jess Brown. He sold it to Delbert McCullough from Anderson in 1963. By this time, it had a main lodge, cottages and trailer spaces on six acres of land. By 1950, it had a dozen cottages for rent, picnic grounds, campsites and trailer spaces.

Gano's Camp was owned by Oscar Gano and was first built in the late 1920s. Located on the north bank of the Big Monon, fishermen liked to stand on the stumps around the camp and fish. At one time, eight stump fishermen were observed catching fish. The Lake Shafer Welfare Association met there for a big fish fry in the 1930s. Despite the Great Depression, the resort continued to grow and added five cottages in 1935. By 1938, it had grown to have fourteen cottages, a trailer park and a picnic area. Nowadays, the Big Monon Trailer Park occupies the space where the camp was once located.

Golden Beach was a resort on the east side of Lake Shafer. It had sixteen cottages in the 1950s, along with a grocery store, playground and boats for rent. It was owned by John and Ruth Albertson. Now, a group of homeowners belong to the Golden Beach Club Home Owners Association.

Greenfield's Log Cabins was located north of Lowe's Bridge on the west side of Lake Shafer. The group of three cabins was owned by Joseph Greenfield.

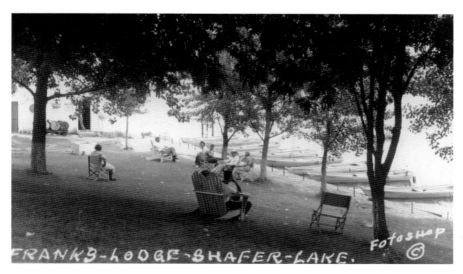

Frank's Lodge was located on the Big Monon and offered boats for rent. *Fotoshop postcard.*

The Harbor Resort began was opened in the 1950s. Known as "the resort on the hill," it sits high on the bank overlooking Kean's Bay. By the end of the century, it was renamed Andrews on the Bay. Then in 2001, it became Pirate's Cove Resort, owned by Cottonwood Resorts LLC.

The Hilltop House Resort was located on Untalulti Drive and had seven cottages, which lasted until the 1990s.

The Holiday Resort opened in 1962 across the Tippecanoe River from downtown Monticello in an area called East Monticello. It was owned by Herb and Marie Pearson. The resort had campsites, a boat launch, a bait and tackle shop, boats for rent, cottages and a trading post. The resort was inundated by the 2008 flood and never recovered. The Twin Lakes Regional Sewer District was going to require its owners to install grinders for the campsites, so they decided to sell the property to Markus D. Rust of Remington in 2011. He has only cleaned up the property.

Eugene "Gene" and Louis Wert purchased two lots on Northwest Shafer Drive on the north side of Honey Creek Bank in May 1949, soon after they married. They built three cottages and named it Idlewild Resort. They rented to "White Gentiles only," according to a 1950 vacation guide. Many cottages and motels had this policy in the 1950s, making it difficult for Black residents from Chicago to rent a place when they came to Ideal Beach and, later, Indiana Beach. "It was for people who only stayed a night or two and didn't need a kitchen," explained the Werts' daughter, Linda Wert Moncel. The place had a boat launch for customers. Louise passed away in 1995, and Gene sold the resort in 2000. "He just couldn't take care of it," said Moncel. The resort was turned into private residences.

Joe-Kate was a former resort located on Kean's Bay. It had five cottages for rent in the 1950s.

Jud's Place was a former resort near Buffalo in the 1930s.

Kell-Cade Park was a resort on the lake in the early days.

Kozy Kove was a resort owned by Harry Whitinger in the 1950s, located on the Big Monon Creek.

The Lake Crest Tourist Court was in East Monticello.

Lake Lodge Cottages was owned by Herman and Margaret Mann. It was located a block from Ideal Beach.

Ledford's Camp was located on the west side of Lake Shafer. Owned by Harlen Skaggs, it had six cottages for rent in the 1950s.

Len-Ray Modern Cabins had two cabins on Indiana Beach Road in the 1950s.

Resorts

Jackman's Lodge was created on Boxman's Place in the 1930s by Forest Jackman. It had a dozen cottages and lasted until 1980. Michael T. Blake took it over and sold it to Mike and Bonnie Triplett, who turned it into the Lighthouse Lodge in the twenty-first century.

Mike's Place was located on the east bank of the Big Monon Creek in the 1950s. It had five cottages for rent.

Oak Crest Lodge had seven cottages and was owned by Lowell and Virginia Amos. It was located eight miles from Monticello on the west side of Lake Shafer.

Parse's Forest Lodge was located at the head of the Big Monon Creek. W.P. Parse purchased one hundred acres of native timber land and turned it into a ranch-type resort in the 1940s. The lodge offered thirty horses to ride. The lodge also had several log and stone cottages for rental along the Big Monon Creek. "First time I ever rode a horse was at Parses," wrote Deborah Westberg Memmer on Facebook. The lodge went out of business in the 1970s. Parses Road is named after the family.

Pat's Tourist Court opened at 401 North Main Street in the 1930s. It is now the site of the Enchanted Garden Flowers and Gifts.

The Pinehurst Resort was located on Lake Shafer in the 1960s. A newspaper reported in July 1964 that a boat ran into a pier at the resort.

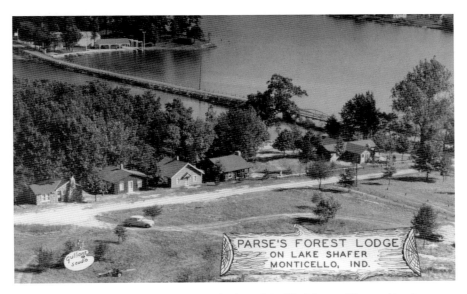

Parse's Forest Lodge was located at the beginning of the Big Monon. The road by the cottages is now called Parse's Road. *White County Historical Museum photograph.*

Reynold's Roost began as a resort in the 1940s on the east side of Lake Shafer. The resort had three cottages. It was sold to Jack and Judy Cochrun in 1986. They decided to name it Mallard Bay Resort and ran it until the COVID-19 pandemic hit in 2020, and now they are trying to sell it.

Riverview Park Resort was on the west side of Lowe's Bridge. The resort was built by Dale Apple. By the 1950s, it had fifteen cottages, a trailer camp and a grocery store. It is now a trailer park.

The Riviera Resort was first built in 1965 on Indiana Beach Road, near the west entrance to the park. The last owner of the resort was William Patel. He sold it to Indiana Beach in 2021, which decided to renovate it.

The Rocky Point Cottages were located on Northwest Shafer Drive, below the parking lot. The cottages were built in 1949 and 1950 by George M. Scurlock, who bought the plans from the Sears catalogue. Steve and Sheila Koontz purchased the cottages in 1995. Steve passed away four months later, and Sheila raised her children there. "It was an interesting place to raise my children," Sheila said. When the Twin Lakes Regional Sewer District was going to charge her seventy-two dollars a month per cottage for sewage starting in 2017, she decided to close the resort in December 2017. "It just

The Silver Shore Resort is now called Shady Resorts. *W.C. Madden photograph.*

Resorts

seemed prudent," she said. She had been tied into the Indiana Beach sewer system, which she had paid $20,000 to do.

Silver Shore Resort was located on the east side of Lake Shafer, near the Isle of Homes. The cottages were built in 1945. Myron and Collette Sterling owned the resort from 1989 to 2018 and sold it to Shady Resorts LLC.

Another resort that changed its name was Trees Resort. It was owned by Mary Jane Wescott, who sold it to John and Mary Walker in 1983. John was a U.S. Navy veteran who had served aboard the USS *Forrestal* during the Vietnam War. The Walkers decided to change the resort's name to Arbor Lights Resort. The resort closed sometime after the COVID-19 pandemic in 2020 and remained closed in 2023.

Urbino's Lakeside Cottages was made up of six cottages owned by John Urbino on Lake Shafer.

Van's Villa was a resort located near Tall Timbers Marina. The villa had four cottages.

White Point Resort was one of the first resorts on Lake Shafer. Nicholas E. White purchased the property by Kean's Bay in 1925. White was the owner of an electric plant and telephone exchange in Moran, Indiana. He built a hotel along with some cottages and marina on Untalulti Drive. The hotel had a grand ballroom with wooden floors and large heavy oak tables and chairs. The hotel burned down in the 1960s.

12

OTHER THINGS LOST

BRIDGES

The first bridge in the county was built in Monticello in 1856 by the Monticello Bridge Company. The company built this bridge, the Washington Street Bridge, to cross the Tippecanoe River from Monticello east toward Logansport. The company was owned by Rowland Hughes.

The wooden bridge spanned from the end of Marion Street across the river to a road that went to Lockport. Hughes also built a toll booth to collect fees to cross over the bridge. The county sold him the land along River Street for the booth. Tolls were necessary, as the bridge had been built by free enterprise, not the government. The bridge was ready to use on March 4, 1856. Heavy ice damaged the bridge in 1864. When it was nearly washed away by a flood in 1866, it had to be rebuilt.

Residents petitioned the county commissioners in early 1870 to build a free bridge to replace the Washington Street Toll Bridge. Contracts were let in April for a two-span wrought-iron bridge. The State of Indiana awarded the contract to Z. King of Cleveland, Ohio, for the price of $8,702.50. The 290-foot-long bridge was ready in the late fall of 1870. It was 18 feet wide. The abutments and pier were constructed using iron, and the supports were of sufficient height to be secure from high water. The contract for the abutments and pier was let to Wheelock, McKay and Goshorn of Fort Wayne. After the pier and abutments were completed, the board of commissioners determined they were too low and asked them to be raised another four feet.

OTHER THINGS LOST

The pier had to be repaired in 1873, and the west abutment began to give way soon after that work was completed. A stone wall was constructed to add additional support in 1883.

The iron bridge remained in place until the late 1890s. The iron bridge began to deteriorate and was condemned by the state, so the residents of East Monticello filed a petition with the commissioners for a new bridge. The bridge was dismantled by James Vernon of Monticello. He shipped it to a factory where it was rebuilt and sold to Cass County.

The construction of the third bridge at this crossing was initiated in May 1898 and completed in 1899. The Wabash Bridge Company erected the steel bridge at a cost of $7,185. The bridge was 284 feet long. A total of 3,224 yards of concrete was poured and 173 tons of steel were used during the construction. The two-span bridge was 20 feet wide with a 6-foot-wide sidewalk.

A sign was put at each end of the bridge that read: "$15.00 FINE FOR DRIVING OVER THIS BRIDGE FASTER THAN A WALK." In those days, most people crossed the bridge by walking, riding a horse or using a wagon. People referred to it as the "White Bridge." A 1919 Monticello map called it an "Iron wagon bridge."

When U.S. 24 was built in the 1920s, eight inches of concrete were added to the bridge surface to handle the autos and trucks that crossed it.

When the bridge was built, it was supposed to last one hundred years. The steel structure cracked during a frigid night on February 15, 1946. Indiana officials closed the bridge to traffic and pedestrians, fearing a strong wind would blow it down. The state developed plans to repair the bridge on April 9. State officials put up a barrier on each side to prevent people from using the bridge; however, this didn't stop everyone. "I would climb over the barrier and cross it at night," admitted Paul Carmichael, a resident of East Monticello. Drivers were forced to use the Tioga Bridge or the Norway Bridge.

A little more than a month after the bridge closed, an adult and child missed being hurt by a few minutes, as they were the last to illegally cross the old bridge before it collapsed at 5:15 p.m. on March 20.

A temporary wooden footbridge was built for pedestrians to use while the new auto bridge was being built. The structure cost $11,900 to build. The bridge was only six feet wide, but that didn't stop a jeep from driving across it illegally, remembered "Bud" Mummert. He said that before the wooden bridge was built, people walked across the railroad bridge nearby, which had a catwalk. It wasn't illegal to use the railroad bridge. Today, you aren't

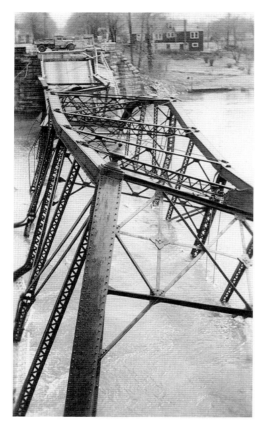

Left: The Washington Street bridge came tumbling down on February 15, 1946. *Rod Pool photograph.*

Below: The Washington Street bridge, built in 1948, lasted until 2014. *Rod Pool photograph.*

OTHER THINGS LOST

allowed to use the bridge for such purposes. Monticello was without the Washington Street Bridge for two years, nine months and twelve days.

Four beams of the old bridge were given to the City of Monticello Parks Department to use as it wanted. "The bridges [in Rotary Cove] are supported by it," said Parks Superintendent Mitch Billeu. The Rotary Club of Monticello built the bridges there.

Engineers took more than a year to figure out what was needed before a contract was let on May 7, 1947, to Smith and Johnson for the construction of the replacement bridge. The company started work on the new structure on June 18.

The new modern concrete structure was 450 feet long and 30 feet wide to accommodate the road surface. The design was that of an open-spandrel concrete arch bridge. Sidewalks were built on both sides of the ridge and were 5 feet, 4 inches wide. A mailbox cutout design was used for the railing. The bridge was 45 feet above the Tippecanoe River and had a twenty-eight-degree curve with a 3 percent grade. By April 9, 1948, five piers for the arches had been completed, and the bridge was one-third of the way done. The company took seventeen months to build the bridge.

The new bridge was dedicated on November 27, 1948, by Indiana governor Ralph F. Gates, and many distinguished guests were in attendance, including Monticello mayor Lloyd Sentz, Senator Roy Conrad and governor-elect Henry F. Schricker. The Twin Lakes High School drum majorettes performed at the ceremony.

Many vehicle accidents followed the construction of this new bridge. Drivers who exceeded the speed limit going downhill and making the curve into East Monticello from the city ended up crashing. The first accident occurred on October 11, 1950. A large GMC truck loaded with cartons of nuts for caterpillar outfits failed to make the turn at about 6:15 a.m. The crash by driver Arthur Roop Jr. from Birmingham, Michigan, resulted in $500 damage to the truck. Bill Luse hauled the truck away with his wrecker.

Another semitruck overturned on March 31, 1973. Robert B. Diffenderfer, age thirty, was headed toward Monticello. When he applied the brakes to make the turn, the load shifted, causing the trailer to roll over. Traffic was blocked for four and a half hours. The truck was owned by Friehauf Transportation Company of Fort Wayne. Damage to the trailer was estimated at about $3,000, and it would cost about $10,000 to repair it. The cab didn't turn over and suffered only about $200 in damage. The cargo suffered about $5,000 in damage.

However, the worst accident on the bridge was not caused by a driver. On April 3, 1974, a tornado ripped through Monticello and lifted a van off the bridge and into the river below. Five out of the six passengers in the van that was headed to Fort Wayne were killed: Elizabeth Scalf, Margaret "Peggy" Stump, Jackie McKelleb, Sharon Miller and Dr. Donald R. Richards. Karen Stotts survived the fifty-foot plunge into the river. "I think it's a miracle I'm alive," said Stotts in one newspaper account. She suffered only a mild concussion.

The bridge lasted for more than thirty years before any work had to be done. The bridge was closed on September 12, 1983, for repairs by Hornback-Sickler Construction Company. The company worked ten hours a day, six days a week to replace the concrete under the blacktop and repair the sidewalk. New lights were also added. The bridge reopened on November 19.

Then the bridge was rehabilitated in 2002. By 2004, more than eight thousand vehicles were going over the bridge daily. One of the worst accidents on the bridge occurred in the winter of 2004. A tanker truck slammed into a car, killing one and injuring three others.

In August 2011, the bridge was given a structurally deficient rating. The deck, superstructure and substructure were rated in serious condition; therefore, it was required for the bridge to be torn down and replaced.

The White County Historical Society and some citizens wanted the bridge saved. It was eligible for the National Register of Historic Places, yet nobody registered it. The rating might have saved the bridge from destruction.

The bridge could have been saved by White County or the City of Monticello; however, both turned down the offer. "They were looking to save a little money," said Monticello mayor Ken Houston. "We couldn't take responsibility for a bridge." The mayor explained that if the city took over the bridge, it would have to pay for inspections, maintenance, insurance and other costs. "It was tempting. It just seemed too far out of reach."

Some people remember the bridge vividly, like Linda K. Johnson Treat of Kissimmee, Florida.

> *I grew up at the foot of the Washington Street Bridge....In the dead of summer, when it was very hot, and it was hard to sleep, I would listen to the lullaby of Peterbilts and Macks and Kenworths, as they would rumble and grumble trying to gear down for "Dead Man's Curve."*
>
> *Once this menace to the hauling man had been successfully navigated, these trucks would growl and strain in an attempt to regain their pride and lost momentum.*

Other Things Lost

And as the sound of this struggle, man against machine, would dwindle out into the darkness of night, I would try to imagine the faces of those men, and the mysterious far-off places which called their names. I would drift into sleep thinking of their loved ones, leading them home by their heartstrings from their long and lonesome journeys....Yes, Washington Street Bridge is a beautiful bridge, and when the dams were closed, and the current was slow, and the surface of the water would calm, it would reflect as a shimmering looking glass.

At those times, when there was not a ripple, the arches of the bridge and their magical reflection portrayed that of two huge eyes. I always felt that bridge was watching over me, and I always felt for that bridge, as one would feel for a secret and trusted friend.

The Indiana Department of Transportation closed the bridge to trucks in mid-May 2014. It was open to only local drivers in cars. One night, a semitruck tried to sneak across the bridge, but it was stopped by police, and the driver faced a $1,000 fine for disobeying the signs. Other truck drivers were also caught trying to cross the old bridge. If they contested the fine, they were usually fined just $130.

Technically, vehicles were permitted to cross the old bridge only when flagmen were available. A sign to that effect was posted on both sides of the bridge. "The problem is they only read the top half of the sign and stopped reading before they got to the part about the flagger," said Monticello police chief Randy Soliday.

One trucker went down Fishers Street, trying to find another way around the detour. He turned into Quentin Court and ran over a stop sign there. Chief Soliday was able to get the name of the employee's trucking company and called them. The company checked the GPS of the truck and found out who was guilty, so the company paid for a new stop sign. One day, another trucker went over the new bridge before it was completed and got stuck in the sand on the other side.

The old Washington Street Bridge was closed on July 2, 2014. The new bridge was opened to cars only the next day. Work on tearing down the old bridge started on July 18. All the work was done by the end of October.

In 2017, the bridge was named after Chief Master Sergeant Dean A. DuVall, a U.S. Air Force airman who went missing in action during the Vietnam War.

The Washington Street Bridge is one of the latest bridges to be replaced in the county.

The second bridge in the county was built in 1858 in Norway. The bridge was constructed by the Norway Bridge Company, owned by David Turpie. The wooden structure was a toll bridge. In 1864, the bridge was wrecked by ice and had to be rebuilt. The new bridge lasted only two years, as it was swept away by a flood in 1866.

No new bridge was built to replace the old one, so local citizens petitioned for a free bridge to be built in the 1870s. They finally got their wish in 1876. A new iron bridge was built by the Wrought Iron Bridge Company for $10,912.30.

The iron structure held firm until the ice rush of 1904. The iron superstructure was lifted clear of its foundation and floated downstream to Monticello, grounding itself at the Washington Street Bridge.

A new bridge was then built at a cost of $8,769 by the Lafayette Engineering Company. It lasted until a modern bridge was constructed in 1970. That 482-foot span withstood the one-hundred-year flood that occurred in January 2008.

In 2020, the bridge in Norway was named after its builder, Donald W. Ward, who designed and worked on the bridge. The top of the bridge was repaved in 2021.

In March 1880, William Spencer petitioned the White County commissioners to build a bridge in the Tioga area to cross the Tippecanoe River into Carroll County. The commissioners wrote a letter to the Carroll County commissioners, who did not reply to the request, so White County went ahead and decided to build a bridge without their help.

In May 1882, the commissioners decided to build a wooden bridge. The Massillion Bridge Company won the bid and constructed the bridge, completing it in January 1883 at a cost of $5,800. The timber piers became a problem due to the ice. Horatio Thornton was hired to make repairs at a cost of $1,900.

In June 1889, the commissioners of both counties met to consider the state of the bridge. County engineers condemned the bridge as unsafe. A wrought-iron truss bridge was recommended to be built with piers of limestone. The Wrought Iron Bridge Company of Canton, Ohio, was given the contract for the ironwork. The bridge was completed by January 1891. The two-span Whipple-truss spanned 450 feet. Some called it the "Paper Mill Bridge," since a paper mill was once located near it.

The pier was a continuing problem, and the counties hired James M. Peirce of Delphi to rebuild the pier in 1901. At the same time, the bridge was refloored and painted.

Other Things Lost

This vintage postcard shows both the Tioga Bridge, which still stands today, in the foreground and the Monon Railroad Bridge that was torn down before the twenty-first century. *White County Historical Museum photograph.*

In 1984, the county commissioners of both counties considered demolishing the old bridge, but it served as a good bridge for people to walk or ride bikes over, since the nearby Green Bridge had no sidewalks. It cost $30,000 to repair the bridge.

In 1994, White County Historical Society director Connie Cascales petitioned the White County commissioners to save the bridge.

In October 1995, the county commissioners of both counties decided it was time to close the bridge to vehicle traffic. The goal was to close it the following spring; however, a Carroll County Road project had to be completed first.

On May 22, 1997, the bridge was closed to traffic and pedestrians, as "BRIDGE CLOSED" signs went up on both sides. The decision to close the bridge to pedestrians and bikers brought about a protest from some twenty citizens, including the Cascales. Their protest resulted in commissioners from both counties reconsidering their decision. They decided to reopen the bridge to pedestrians and bikers on June 19. New signs were put up, and they said, "NO MOTORIZED TRAFFIC." Fishing was also not allowed from the bridge. Shafer and Freeman Lakes Environmental Corporation paid $20,000 to a contractor to conduct a study on raising the bridge, but the project was never undertaken.

Although "no diving" signs are posted on the bridge, people still like to jump into Lake Freeman. It was once the site for a photograph of high school seniors at Twin Lakes High School.

The latest effort to raise the bridge came in 2009, when the county commissioners of Carroll and White Counties discussed the matter. In the end, they decided not to do this, as it would cost more than $1 million to rehabilitate and raise the bridge.

In 2011, the bridge was restored for pedestrian use only. Much of the portal cresting was restored and replicated. It is now considered the longest of a handful of Whipple-truss bridges remaining in the state.

In 1938, the state decided a new bridge was needed in the Lake Freeman/Tioga area for State Route 39 and U.S. Highway 421, so a bridge was built just south of the Tioga Bridge to handle the heavier traffic between Monticello and Delphi. Built by the W.C. Babcock Grain Company, the bridge was a Parker through truss design, with two spans. The bridge was 505.9 feet long and 24 feet wide with a vertical clearance of 14.5 feet. It was rehabilitated in 1978. Some people called it the "Green Bridge" for its color, or the "Madam Carroll Bridge" due to the boat dock nearby on the Carroll County side of the bridge.

In August 1996, the state unveiled plans for a new bridge to replace the aging structure, as it was showing signs of deterioration. The new bridge was

Another bridge in the Tioga area was called the Tioga Bridge, according to this vintage postcard. Others called it the "Green Bridge," based on its color. *White County Historical Museum photograph.*

to be built about fifty feet to the right and west of the aging structure. This prompted Bill Luse and Max Grist to object to the new bridge, as the state would take both of their structures in the process. In response, the state altered its plans and ended up taking only one of the buildings. Luse refused the state's offer for his land, so it said it would condemn the land and take it anyway.

In April 1999, the state announced that the construction of the new bridge would begin on April 1, 2000. "The state's planned project has already begun to hurt the Madam Carroll's business," said Luse, according to the *Herald Journal*. He would lose some of his close-by parking area. Much of his parking would have to be relocated across the street after the bridge was completed.

The bridge was demolished in 2000 to make way for a new bridge that was named after Captain Bill Luse, the former owner and captain of the *Madam Carroll* paddleboat located on the Carroll County side of the lake next to the bridge.

The Monon Railroad built a bridge south of Monticello over the Tippecanoe River in the late 1800s to accommodate a train that went from Indianapolis to Chicago with a stop in Monticello.

The railroad stopped using the bridge in 1993, when the Indianapolis to Chicago train was stopped. In 1994, the tracks were removed from the bridge in preparation to take down the bridge.

On August 21, 1995, William Paul Robert had been drinking with some friends when he decided to dive off the bridge into the five feet of water below. He died in the attempt. An autopsy revealed the thirty-five-year-old man had a blood alcohol content three times the legal limit for driving—.299. His body was found by a six-member dive team from the Monticello Fire Department, who arrived soon after a 911 call.

Before the end of the century, the bridge was taken down.

CARRIAGE HOUSES

A carriage house was an outbuilding usually located behind or next to a home that was used to house horse-drawn carriages. There were a couple of these houses in the county in the 1800s, but with the coming of the automobile, they became obsolete. Now, the old carriage houses are used as car garages or additional housing units.

One carriage house in Monticello was located behind a home on North Illinois Street. The house was built in 1860, and the carriage house was built in

This building was originally a carriage house and housed a horse and wagon for the owner of the home on North Illinois Street. *Dorothy Salvo Benson photograph.*

1900, according to White County property records. The home was later taken over by a plumbing business for a while. Now, the nine-hundred-square-foot structure is a rental house with two small bedrooms and one bathroom.

Another carriage house in Monticello was located next to the first mayor's home and built in 1905. It was added onto later and converted into a home.

FERRIES

Before bridges were built to cross the Tippecanoe River, ferries were common along the river. The first ferry driver in the county was Peter Martin, who was granted a five-year license on May 3, 1837, to provide a boat sufficient to carry a wagon and four horses or eight men across the river. The ferry service was located midway between Washington Street and Broadway in Monticello. The location had a steep drop, however, and the ferry service was later moved north a block and half to the foot of Marion Street.

A county agent took over the driving duties in October 1839. Then James A. Clark took over the service in March 1843 and ran it for three years. He was succeeded by John R. Willey and then William Wolf. In June 1851, James L. Pauley took over the service.

In the 1840s, a ferry service was started in Norway. However, it was discontinued in 1858, when a wooden bridge was built at the location. The bridge was washed away by a flood in 1866, so the ferry service was used again until a new bridge was built in 1876.

Another ferry service was used near Springboro to cross from White County into Carroll County. The service lasted until a bridge could be built there.

Other Things Lost

Others decided to get into the ferry service in 1853. John Hillman applied for a license to conduct a ferry near the Hillman sawmill between Monticello and the Tioga area. Zebullon Sheets also obtained a license at the same time on the east side of the Tippecanoe River. The old ferry service by Marion Street was abandoned, and its boats were sold to Moses Sheetz for $105.

Costs for the service ranged from six and a quarter cents for a man on foot to sixty-two and a half cents for a wagon and four horses or cattle. The rates doubled in cases of high water or ice. Back then, some British currency was still in use, which made a portion of a penny possible.

A ferry at the time was a good-sized flatboat with a hinged apron at each end; when let down, these aprons served as gangplanks for men and animals. A wire cable on two pulleys that ran tandem was stretched across the river some distance above the ferry line. To this cable, the boat was swung by two lines of rope, which extended from the pulley block to a windlass on the upstream side of the boat in such a way that as one rope was wound, the other was unwound. By turning the windlass, the boat was set obliquely to the channel and was propelled across the river by the force of the current on the same principle as a kit is raised.

Ferry service came to an end as bridges were built in the county.

FOB WATCH

In May 2023, Brad Schultz came across an interesting find in Florida. "My sister was selling her house, and she gave me a dresser," said the yacht captain. He was going through the drawers and found a fob watch. "It was behind the drawer in the corner." The inscription on the back of the pocket watch reads: "Presented to Duncan Kerr, February 22, 1921, By Thornton Williams Post 81, Monticello."

The fob watch was made by the Elgin National Watch Company and has seventeen jewels in it. Fob watches were very popular in the twentieth century and were also called pocket watches. They had a chain so that they could be attached to clothing. Their popularity diminished when wrist watches started becoming popular in the 1920s.

This fob watch was sent back to American Legion Post 81, which presented it to Duncan Kerr on February 22, 1921. *W.C. Madden photograph.*

Schultz decided to send the watch to the American Legion Post in Monticello. To go along with the watch, he wrote a note: "I hope you can return it to its rightful owner."

The watch and note arrived in Monticello a few days later, so Commander Tom Mowrer decided to inform the board about the watch. Kerr was not one of the founders of the post, which was first founded on September 16, 1919, nor was he ever a commander of the post, according to the book *100-Year History of American Legion Post #81 Monticello Indiana*.

A local newspaper, *News and Review*, wrote a story about the watch and made a post on Facebook with the story. As a result, Lorie Ehrlich Amick did some research into the subject and found some newspaper clippings that helped explain why Duncan Kerr received the watch. Kerr was the director of a minstrel musical production that performed at the Legion on February 21 and February 22, 1921. The watch had been presented to Kerr on February 22.

More research found that Kerr was born in Scotland on August 8, 1887. He immigrated to America at the age of seventeen in 1904. On August 1, 1907, the nineteen-year-old married Eleanor Martin in Central Falls, Rhode Island. They had four children: Duncan Jr. in 1908, Mary in 1911, Anna in 1913 and Thomas in 1917. He moved from Rhode Island to Monticello in 1919 to replace James McCallum at the Thread Mill Company. He became extremely active in the community, both in the choir of the Methodist church and in other musical performances conducted in the area.

In 1923, Kerr left for Detroit to accept a position with Dean and Sherk Corporation. He took a job in the dye department, which was similar to his job in Monticello. In 1924, he filed for divorce and was remarried the same year. He retired in 1956 and moved to Florida, where he died in 1980.

A Monticello woman saw the story and contacted the Legion, as she thought she was related to Kerr; however, she couldn't prove she was a relative, so the watch remains with the Legion.

Mowrer checked with a local jewelry company about fixing the watch, but they told him they couldn't repair it. He planned to display the watch at the Legion. "I'd rather see the family have it," Mowrer said.

GRACE HOUSE

In 1998, a woman and her child named Grace came to the St. Mary's Episcopal Church in Monticello looking for a place to live. The church took

OTHER THINGS LOST

her in and opened a shelter for women. The shelter was named Grace House after the child. The shelter, which was built in 1900, was located in a house on North Bluff Street. The house was the site of the first hospital in the town.

Grace House could take up to ten homeless women and their children a one time. They were provided with shelter, food and clothing. "We try to get them back on their feet," said Robin Armstrong, a board member. The shelter depended on donations from county churches and individuals. The shelter was closed in May 2009 after funding dried up. The house now belongs to Kenneth Felker.

LAKEVIEW HOME

Lakeview Home finally met its demise in 2017, when the new owners decided they didn't want the structure. They were only interested in selling the land for $1 million.

Before it was torn down, Julie Gutwein and Kean MacOwan, the president of the White County Historical Society, tried in vain to stop the demolition. The building was in the National Register of Historic Places; however, under federal law, the listing of a property in the National Register of Historic Places puts no restrictions on what a nonfederal owner may do with their property, up to and including destruction.

The building had been purchased at auction after White County commissioners decided to rid themselves of the expense of trying to maintain the old structure that was more than a century old. It was like an old car that had seen better days. Repair and upkeep cost more than it was worth. The few remaining residents could find another place to live with some government assistance.

The building came about in 1907, when White County officials voted to construct a new county infirmary. The commissioners and county council purchased 150 acres from Daniel McCuaig for $16,500 in Union Township near the Tippecanoe River. Then Samuel Young, a local architect, was awarded a contract of $33,364.91 to build a facility. It would be large enough to house forty-eight people, plus a superintendent and his family. The two-story structure would have a bath and toilet on each floor. The building's heat would come from steam provided by a coal furnace in the basement. An eight-horsepower engine would provide the electricity and run the water system. Men and women would live separately in the facility. Residents would come and go as their health or situation changed.

The White County Asylum eventually became known as the Lakeview Home, a place for low-income residents. *White County Historical Museum photograph.*

The facility was officially known as the White County Asylum, but people called it the "County Farm," or "Poor Farm," as people who lived there didn't have the finances to live elsewhere. It was a good place for the homeless and those in need of assistance. Back then, most counties had such facilities, and some had insane asylums and juvenile asylums. This facility did have two jail cells in its basement, and they were used when necessary. The facility was opened on June 16, 1908.

If anyone died while living at the home, they could be buried at a nearby cemetery known as the Norway Cemetery, which had been there for years before the home was built.

In 1925, the facility became known as the Lakeview Home. Then in 1943, an infirmary unit was added upstairs in wing E, and Dr. G.R. Coffin was the county physician for the facility.

The National Health Services Act of 1946 came into effect in 1948, and the Poor Law System was abolished. The "County Farm" became part of the local welfare system.

The Friends of Lakeview Home came into being and helped raise money for the facility. In 1985, the donations paid for a chair lift to be installed to help residents climb stairs. The facility had no elevator.

In the mid-1990s, Deven Seward went to work there as a cleaning lady. She found the building was haunted. "One room in particular on the second floor was haunted," Seward explained. "When we cleaned that room, if

you didn't turn the light on, the door would slam behind us. And in the kitchen, you could see shadows and hear pans moving around at night." In the wine cellar, they would find broken bottles every time they went down there. "There was no way they'd fall off the racks," she said. They had to clean up the mess, of course.

One time, when Seward looked down the laundry chute, she swears she saw someone in the basement. "It was creepy," she said. Her mother would never get out of the car when she dropped off Seward, as she didn't like the place and wouldn't go inside. Seward was there only a short time, but she loved "the castle," as she and some others called it. "So sad to see it torn down."

ORPHANAGE

In the late 1800s, a group of women started a home for poor or orphaned children in Monticello. The home was called the White County Orphan's Home Association and was established on property belonging to Mrs. Cornelia Logan on the corner of South Bluff and Market Streets.

Mrs. Scott was the matron of the association for several years before Mrs. S.R. Temple succeeded her. For several years after the institution was established, there were no funds in the county treasury, and the women of the organization paid for the tuition and yearly support for the children— sometimes as many as fifteen—themselves.

Around the turn of the twentieth century, a law was passed governing the care for charity children. By this act, parents were required to relinquish all claims to the children they placed in a charitable institution of this kind. As few of the parents would consent to such a sacrifice, the home in Monticello did not have enough occupants to warrant its continuance, and from that time on, children needing homes were sent to Lafayette or Indianapolis.

Nowadays, the Department of Children Services takes care of orphans.

ABOUT THE AUTHORS

Dorothy Salvo Benson grew up in South Florida in a Catholic Sicilian home. She relocated to Indiana, where she is now a teacher with a master's degree in education. She has written several books about the paranormal for The History Press using the pen names Dorothy Salvo Davis and Maria Salvo. She enjoys researching and writing about history.

W.C. Madden learned how to write courtesy of the U.S. Air Force. He became a journalist in the military and achieved many awards before retiring in 1986 after a twenty-year career. Then he received his bachelor's degree through the GI Bill. He wrote his first book while still in the air force and has now authored forty-five of them. Many of those books have been published by The History Press and Arcadia Publishing. Madden retired in 2023 but still does freelance writing for a newspaper and still writes books. He thanks his creator every day for his talent.